Paul Cézanne

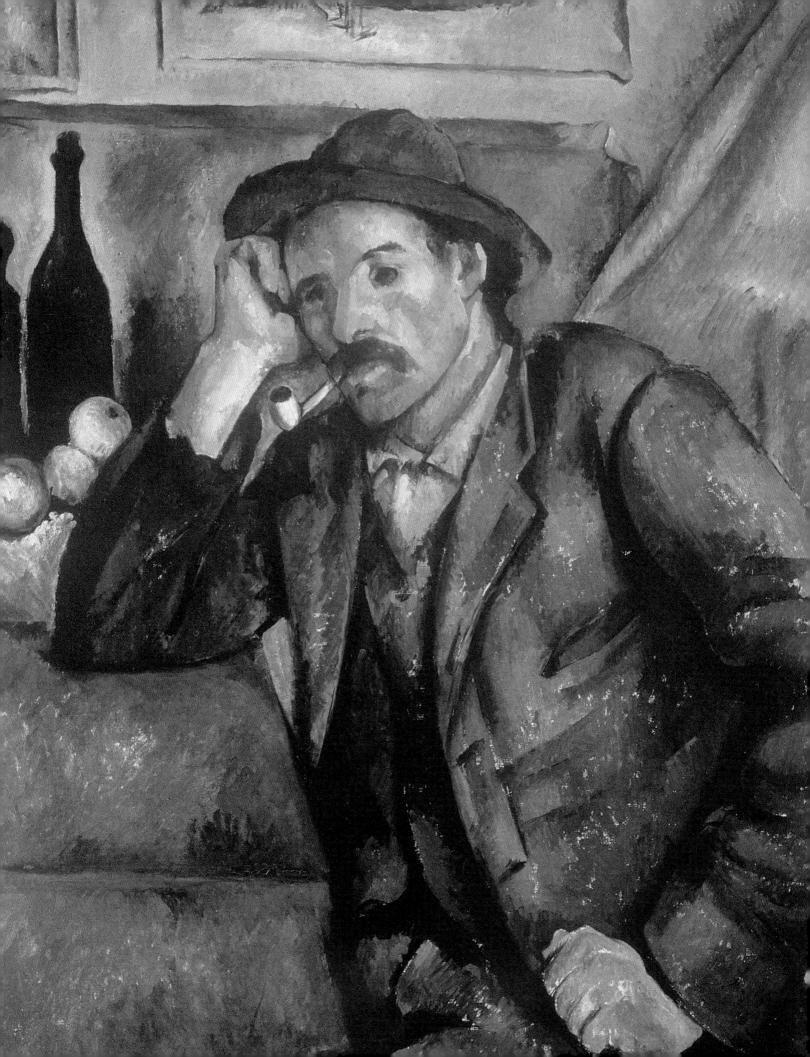

THE
GREAT
ARTISTS

Paul Cézanne

Jane Bingham

SIRIUS

SIRIUS

This edition published in 2019 by Sirius Publishing, a division of
Arcturus Publishing Limited,
26/27 Bickels Yard, 151–153 Bermondsey Street,
London SE1 3HA

ISBN: 978-1-78950-721-8
AD006172UK

Printed in China

CONTENTS

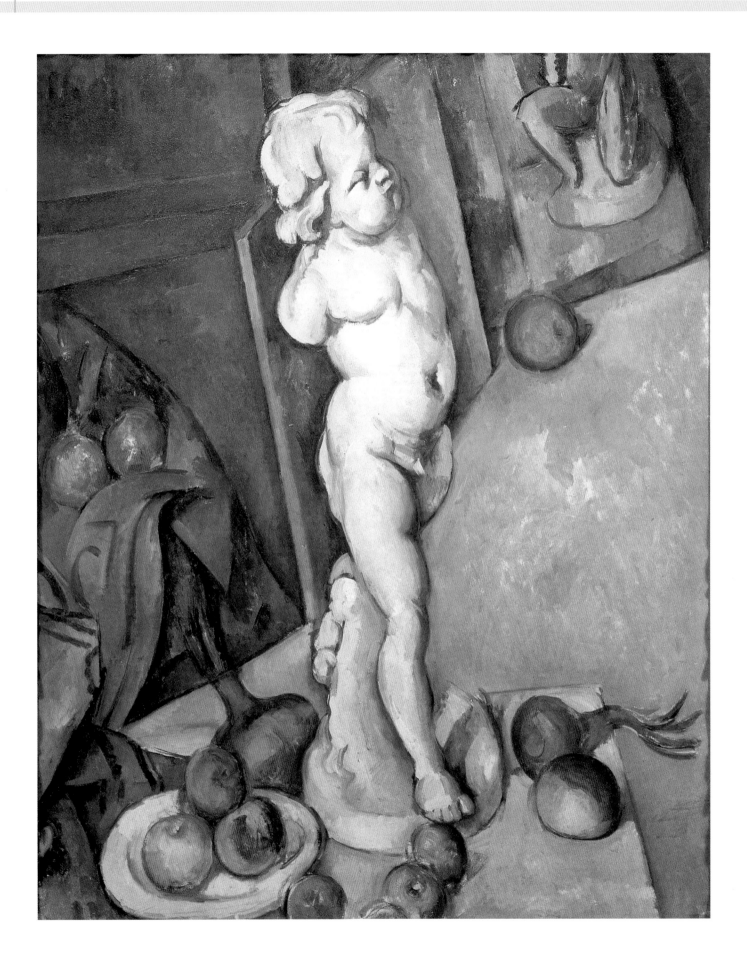

INTRODUCTION

Paul Cézanne (1839–1906) is one of the outstanding artists of the modern age. In the words of Pablo Picasso, he was quite simply the 'father of us all', the artist whose work changed the course of modern art. He has been hailed as a leading Post-Impressionist and a vital link between the Impressionist and Cubist movements. In fact, his painting defies all labels. Throughout his life, Cézanne worked tirelessly to create a body of work that reflected his very personal response to the world around him.

Unlike many of his artist contemporaries, Cézanne had a largely uneventful life. After a boyhood spent in Aix-en-Provence, he moved to Paris in his early twenties, where he met a group of young artists who would later become known as the Impressionists. Among them was Camille Pissarro, with whom he formed a close friendship; the two years he spent working with Pissarro proved to be a crucial time in his artistic development. After this period he retreated to Provence, where he spent most of his time painting in solitude. Even though he had a wife and son, he preferred to live apart from them, filling his life with painting.

Cézanne painted with oils and watercolours and produced thousands of drawings. He was equally accomplished at landscape painting, portrait painting and still lifes, and within these genres he concentrated on a limited number of subjects. As a portrait painter, he turned to the same small cast of people many times. His wife, Hortense, and son, Paul, were frequent models, and he produced masterful studies of local Provençal characters. For his still lifes, he painted the same objects repeatedly, each time trying out different combinations. As a landscape painter, he kept returning to the same scenes, most of them within a few miles of his childhood home.

Cézanne's art evolved throughout his lifetime, but it is possible to identify four distinct phases in his artistic journey. As a young man, he produced work that was dark, dramatic and confrontational. In his early thirties, he experienced an artistic breakthrough when Pissarro encouraged him to eradicate dark colours and strong outlines from his palette and he adopted a lighter, brighter style, using a technique of applying small patches of colour to the canvas. This change was followed by a long period of exploration, in which he developed a method of using brushstrokes that aimed to reproduce the underlying structure of what he saw. Finally, in the last few years of his life, he refined his painting technique, creating a series of landscapes featuring Mont Sainte-Victoire as well as working on his large-scale canvases of *The Bathers*.

This book is part of a series introducing great artists who changed the course of art. It charts Cézanne's journey as an artist, exploring the places where he lived and worked, his mainly solitary personal life, and the artistic influences that helped to shape his remarkable vision of the world.

Still Life with Plaster Cupid, c.1894. *This striking composition dates from Cézanne's mature period when he was exploring colour, depth and form. Its juxtaposition of contrasting objects and its use of bold framing and shifting viewpoints are all typical of Cézanne's later work.*

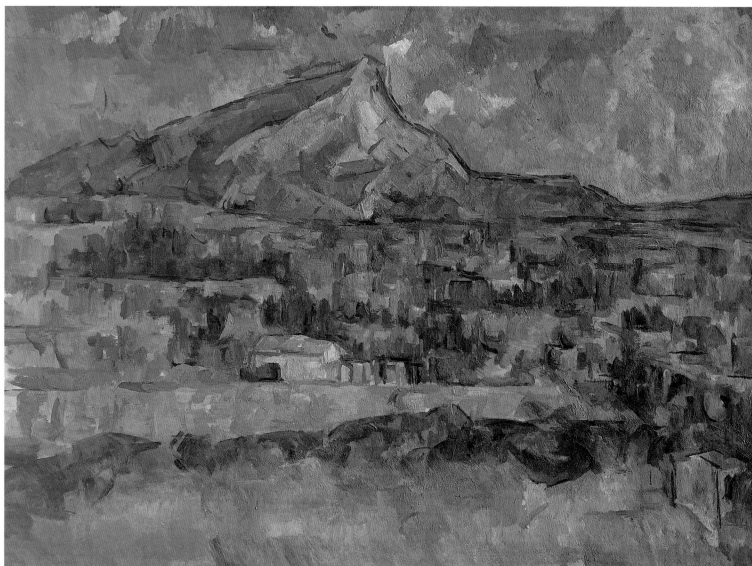

Mont Sainte-Victoire, c.1902–6. *Cézanne's birthplace of Aix-en-Provence was to become one of his favourite subjects. This study, painted near the end of his life, shows the town nestling under the peak of Mont Sainte-Victoire.*

CHAPTER 1
Early Years

The picturesque town of Aix-en-Provence lies at the heart of Paul Cézanne's life and art. It was there he was born in 1839 and there he died, 67 years later, having devoted much of his life to painting the surrounding landscape. The countryside of Provence – its woods, fields and rivers, its rocky outcrops and isolated farms – was a source of inspiration to the young Cézanne, but his childhood was not a time of perfect happiness. While his mother was loving and supportive, his father, Louis-Auguste Cézanne, was a man of driving ambition who had a troubled relationship with his sensitive son.

FAMILY AND EARLY CHILDHOOD

Cézanne's parents both came from humble origins. His father, Louis-Auguste, was the son of a tailor in a small village outside Marseille. As a young man he had moved first to Aix to work for a wool merchant, and then to Paris where he trained as a hat-maker. Louis-Auguste returned to Aix at the age of 24 and very soon established his own business with two partners. The firm, which sold and exported felt hats, was a great success and by the time of Cézanne's birth his father had become a wealthy and respected member of the bourgeoisie of Aix.

Louis-Auguste met his future wife, Anne-Elisabeth-Honorine Aubert, while she was working in his hat-making company. The daughter of a woodturner, she was 24 at the time of their first meeting, while Louis-Auguste was approaching 40. Soon the couple were living together and it wasn't long before Elisabeth became pregnant. Paul was born in 1839, followed by a sister, Marie, in 1841. The couple did not marry until Paul was five years old, but this was not unusual in French rural society. A third child, Rose, was born in 1854; however, the 15-year gap between Paul and his younger sister meant that they never had a close relationship.

At the age of five Paul began school, and Marie soon followed. The children attended a small primary school before moving on to the École Saint-Joseph, where Paul stayed for three years. In later life, Marie wrote a letter to Cézanne's son, recalling those early schooldays. She told him that her big brother took much trouble to look after her, remaining gentle towards her even when she provoked him, and she described him as 'a quiet and docile student [who] worked hard [and] had a good mind, but did not manifest any remarkable qualities.' It was not until he moved to the Collège Bourbon that Paul began to come into his own.

The Painter's Father,
Louis-Auguste Cézanne,
c.1865. *Louis-Auguste
had a forceful personality
and dominated his son's
life for many years. A
determined individualist,
he liked to wear examples
of the headwear made by
his company.*

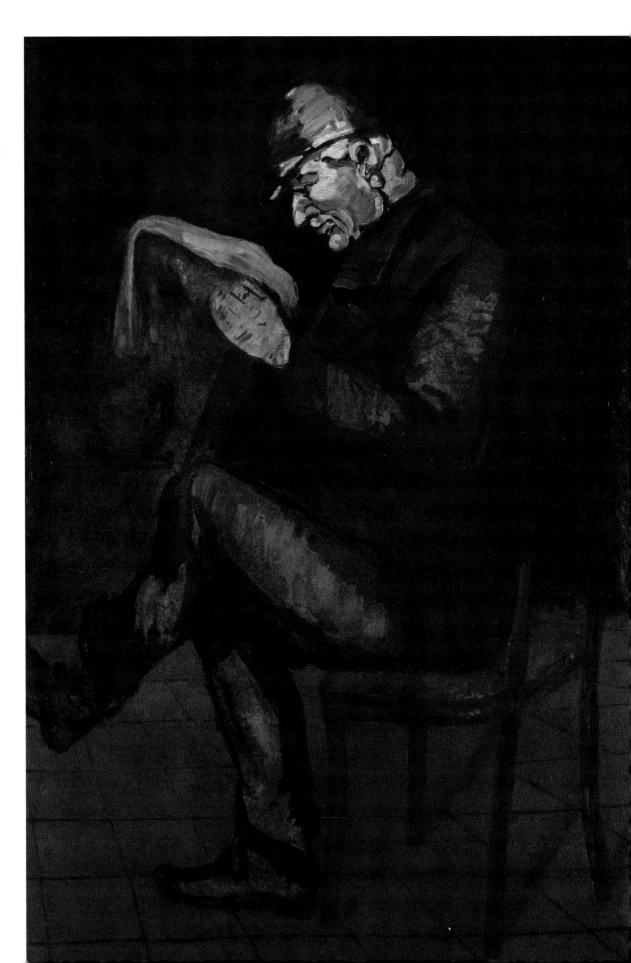

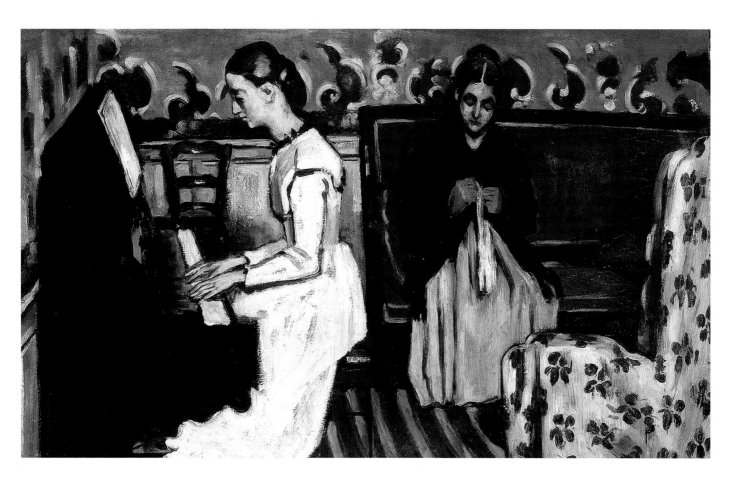

Girl at the Piano –
Overture to Tannhauser,
c.1868. *Very few images
of Cézanne's childhood
survive, but this picture,
painted in his early, heavy
style, shows his mother
and sister Marie in the
family home at Aix.*

SCHOOL AND FRIENDSHIP

In 1852, the 13-year-old Cézanne joined the Collège Bourbon as a day boarder, leaving home at 7am and returning only to sleep. In his six years at the Collège, he gained a solid education and some lifelong friends. In particular, his friendship with two other boys was so close that they became known as 'the Inseparables'. Cézanne's young companions were Baptistin Baille, who came from a wealthy family in Aix, and a lively little Parisian called Émile Zola. In later life, Baille was a professor of optics and acoustics in Paris, while Zola became one of France's leading novelists and playwrights.

At school, the three Inseparables worked hard at their studies, but also enjoyed some harmless fun, devising playful nicknames for their teachers and playing practical jokes. According to Zola's fictionalized account of his schooldays, the friends smoked dried chestnut leaves in homemade pipes while the young Cézanne experimented with setting fire to insects. After school, the trio often gathered in an upstairs room of Baille's house, where they brewed up strange potions and composed plays in rhyming verse that they directed and acted in themselves.

The friends were united in their love of fun and adventure, but Cézanne was the most volatile of the three, suddenly plunging into fits of depression and self-doubt. At these times he would say 'The sky of the future is very dark for me!' but then he would recover and begin to plan his next exciting scheme. He also suffered from fits of temper and would suddenly fly into a rage and insult his friends. Zola counselled Baille, 'When he

CÉZANNE AND ZOLA: THE START OF A LONG FRIENDSHIP

When he arrived at the Collège Bourbon at the age of 12, Émile Zola already showed signs of the character that would later make him one of France's most outspoken literary figures. Widely read and opinionated, with a strong Parisian accent, he was also poor and undersized, and he stood out immediately from his stocky Provençal classmates. His father was a talented engineer who had moved to Aix to construct the dam that was later named after him, but he had died when Émile was six years old, leaving him in the care of his doting mother and grandmother. Young Émile was awarded a scholarship to board at the Collège, but his mother and grandmother still insisted on visiting him every day at school. Perhaps unsurprisingly, he was teased mercilessly by his fellow pupils, who taunted him for his accent and his poverty and even resorted to violence, giving him regular beatings.

Fortunately for Émile, he found a determined champion in Paul Cézanne. At the age of 13, Paul was almost fully grown – tall, broad and physically confident. Shocked by the cruelty of his fellow pupils, he waded in to protect the younger boy, lashing out at his tormentors. Paul's outraged defence brought positive results: the bullies retreated and he and Émile became firm friends. The next day, Émile brought Paul a basket of apples as a thank-you present. It was the start of a friendship that would last for over 30 years, as the two remarkable characters nourished each other's talents.

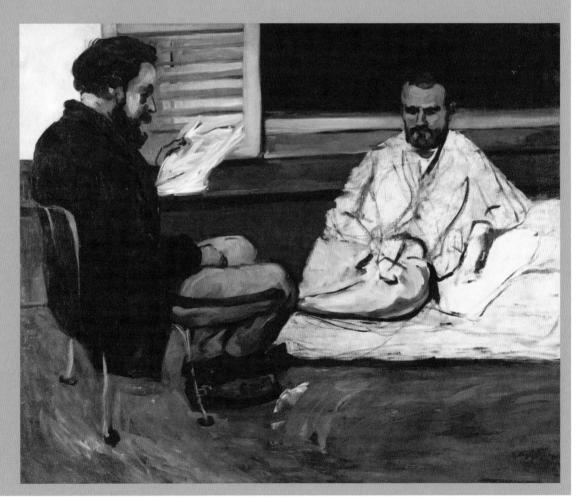

Paul Alexis Reading to Émile Zola, 1869–70. This portrait of the 30-year-old Zola shows him listening to his friend Alexis, a writer and art critic. Zola's light-coloured costume and seated pose lend him an air of remoteness and wisdom.

hurts you, you must not blame his heart, but rather the evil demon which beclouds his thought. He has a heart of gold and is a friend who is able to understand us, being just as mad as we, and just as much of a dreamer.'

Apart from the fun of friendship, life at the Collège Bourbon was tough. The classrooms were unheated, the boys learned to swim in a pond covered with slime and the food was so bad that pupils sometimes resorted to riots at mealtimes. Yet, despite these privations, the boys did not experience deliberate cruelty. Pupils who broke the school rules were generally forced to write out 500 lines of 'improving' poetry, rather than being punished by beatings.

Teaching at the Collège was generally uninspired, although Cézanne did manage to acquire a deep knowledge of Latin and Greek as well as a thorough grounding in arithmetic, history and geography. A diligent pupil, he earned an array of prizes, especially for his Latin and Greek translations. He enjoyed playing the cornet in the

Large Pine and Red Earth, *1895–7. The countryside around Aix-en-Provence, with its streams, rocks and trees, was the perfect adventure ground for Cézanne and his friends. Later, his idyllic memories helped to inform his passion for the landscape.*

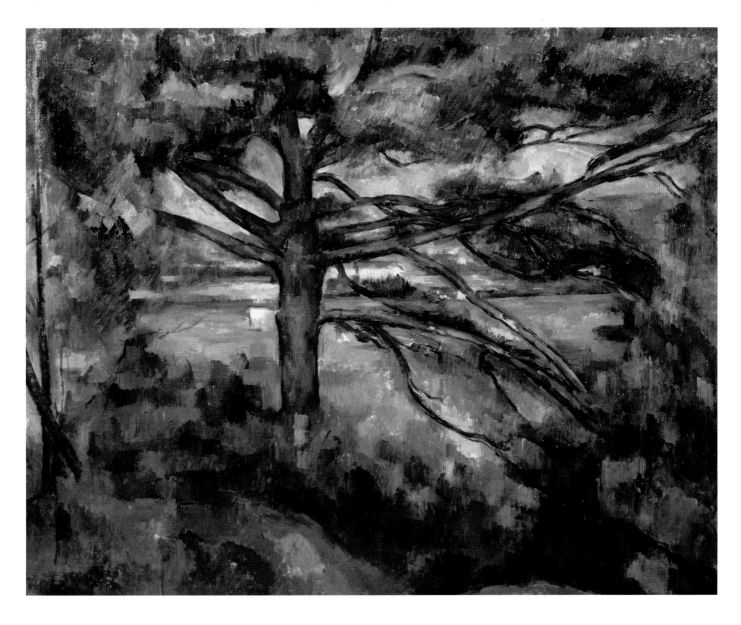

school band, and sometimes made up a trio with his friends to serenade the girls they admired. Surprisingly, he failed to shine in art. Instead, it was Zola who won prizes for drawing.

RURAL ADVENTURES

Whenever they had the chance, the three Inseparables would pack up a picnic and a bag of books and escape into the countryside. Often, they left in the early hours of the morning so that they could enjoy the sunrise. In summer, they swam naked in streams, before stretching out in the sun to dry. In winter, they trekked through snowy woods and built fires to cook their simple meals. Even on rainy days, they still ventured out, huddling in gullies and reading poetry to each other. Sometimes they carried their guns and took potshots at birds, but mainly they just talked, sharing their love of poetry and their dreams for the future. It was a magical time that Cézanne would remember for the rest of his life.

Study of Bathers, 1892–4. Cézanne's fascination with outdoor bathing had its origins in his boyhood swimming expeditions with friends. In his final years, he produced a set of monumental studies of bathers, along with smaller works on the same theme.

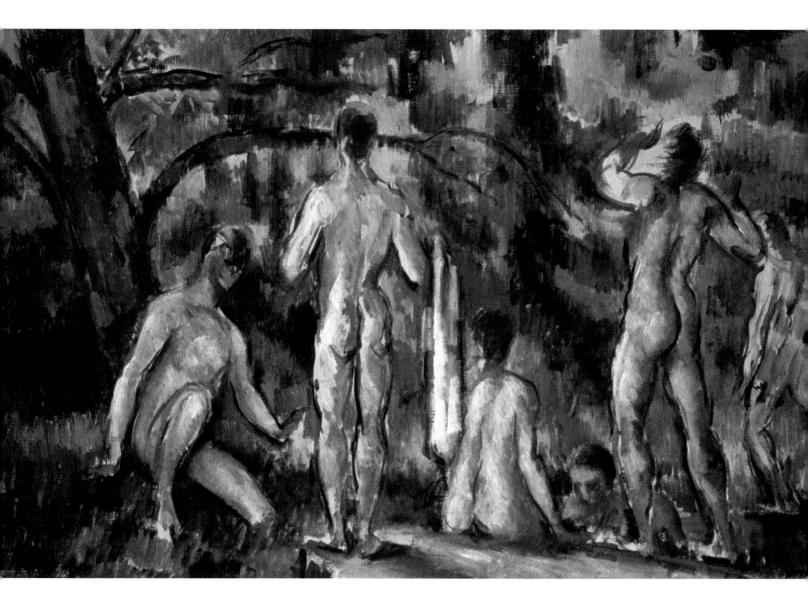

The Artist's Mother, *1866–7. For this portrait, Cézanne used a palette knife to apply the paint in heavy strokes. The painting shows a striking woman with a rather wistful expression and a strong resemblance to her son.*

The Artist's Sister, *1866–7. This portrait of Cézanne's sister Marie was painted on the reverse of his portrait of his mother. Marie never married and maintained a strong bond with her brother throughout his life, although her excessive piety often infuriated him.*

FAMILY FEELINGS

By the time Cézanne enrolled at the Collège Bourbon, his father was a very wealthy man. Five years earlier, Aix's only bank had gone bankrupt and Louis-Auguste had seized the opportunity to take ownership of one of the town's key institutions. In partnership with the bank's cashier, Joseph Cabassol, he founded the new bank of Cézanne and Cabassol, offering loans to the people of Aix. The partnership prospered and Louis-Auguste became a leading citizen of Aix – wealthy, respected and a little feared.

Louis-Auguste ruled his family with a firm hand. Generally grim and unbending, he demanded total obedience from his children. He expected them all to be firm and decisive – one of his favourite sayings was 'Every time you go out, know where you're going!' – and his expectations of his only son were especially high. Marie, his favourite child, was sometimes able to humour him out of his grim moods, but Paul would creep away, turning to his more warm-hearted mother for comfort.

Very little is known about Cézanne's mother, Elisabeth, but she was clearly not an educated woman. At the time of her marriage, she appears to have been illiterate; while Louis-Auguste signed the marriage documents, it was recorded that his bride and her mother did not have the skill of writing. However, Elisabeth seems to have gained some literacy skills later in life; by the time her son was six years old she was able to write her name in a book that she gave to him. No letters from Elisabeth survive, and her granddaughter reported that she was not in the habit of writing. However, she could certainly read, and Cézanne wrote to her regularly when they were apart. She also appears to have had some feeling for art, subscribing to illustrated magazines – *L'Artiste* and *Le Magasin Pittoresque* – which provided a useful source of images for her son.

Unlike her husband, who had no time for artists, Elisabeth fostered Paul's artistic talents. When he was very young, she encouraged him to colour in the images in her magazines and praised him for his drawings, and she was touchingly sure that her son would grow up to be a great artist. Marie Cézanne later described how her mother liked to mention the names of Paul Rembrandt and Paul Rubens and call her children's attention to the shared forename of these great artists and her son. Cézanne would remain close to his mother until her death at the age of 83, and she provided a constant source of support for him, even though she never fully understood his artistic aims.

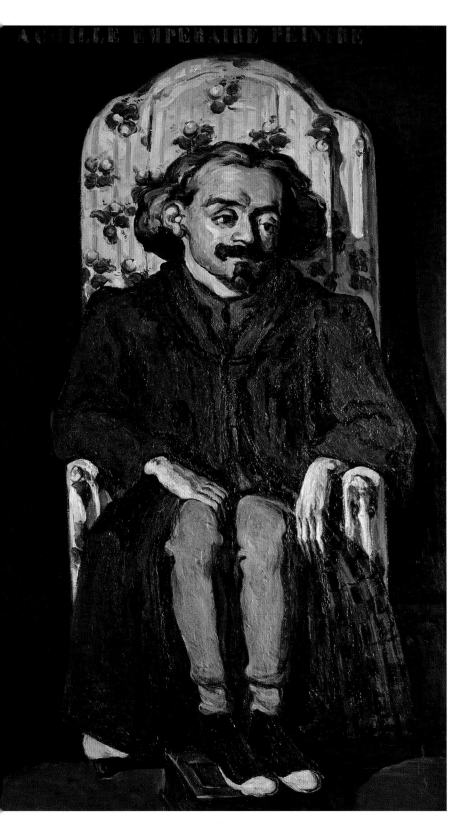

Portrait of the Painter Achille Empéraire, 1867–8. In this striking portrait, Empéraire is seated on the same chair that Cézanne's father occupied for his portrait (see opposite), but here the chair becomes a throne, somehow emphasizing the sitter's defiant spirit.

FINDING ART

Cézanne's boyhood ambitions focused mainly on becoming a famous poet. He was a versatile writer who could compose epics in the style of Virgil, emulate the work of modern masters such as Baudelaire and turn out doggerel to amuse his friends. Zola saw great promise in Cézanne's writing, even acknowledging that he had the potential to become the better writer of the two, although he doubted whether his friend had the dedication to pursue a literary career.

Gradually, however, Cézanne's ambitions took a different direction as he began to nurture dreams of becoming a painter. His sketching had gradually become more accomplished and at the age of 18 he enrolled as a part-time student at the town's free school of drawing. The school was linked to the Musée d'Aix and its drawing master, Joseph Gilbert, also acted as curator of the museum. Gilbert was a strict and unimaginative teacher who instructed his pupils on the art of figure drawing, insisting that they should follow rigid rules on size, scale and degree of shading. Students copied 'gothic types', 'antique statues' and occasional nude male models. Gilbert demanded total dedication to art. Drawing sessions lasted for two hours, often in freezing conditions, and pupils were forbidden to leave even for the purpose of going to the toilet.

Cézanne made a lasting friend at his drawing class. Achille Empéraire was a talented artist who later became the model for several of his portraits. He had a disability that meant that his body was extremely small, with very thin arms and legs, but he was nevertheless handsome and compelling, and, like Cézanne, a passionate reader and dreamer. Cézanne also managed to find other models to paint, including at least one girl who was probably his sister Marie. Cézanne's letters from this period reveal that he saw girls as distant creatures who could only be admired from afar. Yet, despite his efforts to improve his drawing skills, his dream of becoming an artist still seemed impossible to realize.

FAMILY CRITICS

None of Cézanne's family appreciated his art. For his father, art was simply a waste of time. He once told his son, 'One dies with genius, but one eats with money.' His mother's favourite picture by her son was the copy he made as a teenager of an uninspiring painting in their local museum. Rose took no interest in her brother's work and even Marie did not admire his art. At the time of her death, Marie had just one painting by Cézanne. When a visitor commented on the picture, she replied, 'I have that Saint-Victoire because my brother forced me to take it, and so as not to upset him. I never understood and still don't understand anything about my brother's painting!'

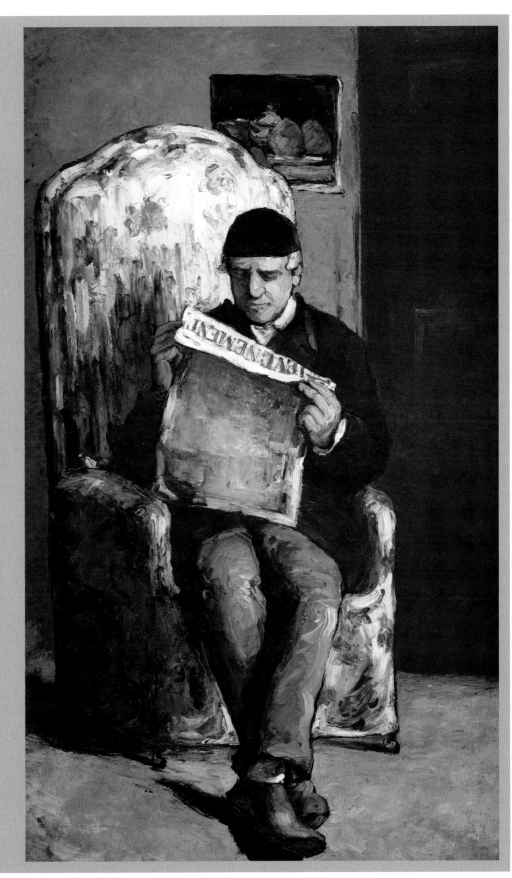

Louis-Auguste Cézanne, the Artist's Father, Reading 'L'Événement', 1866. This study of Louis-Auguste, painted when Cézanne was 27 years old, conveys a sense of his father's dignity and authority. However, the choice of newspaper can be seen as a small act of rebellion. L'Événement was not Louis-Auguste's usual journal; it was used by Zola as a mouthpiece for his radical views on art.

THE WIDER PICTURE

While life in Aix-en-Provence remained largely tranquil and unchanged during Cézanne's youth, the period 1840–60 was a time of great upheaval, both in France and in the wider world. By the 1840s the effects of the Industrial Revolution were being felt across Europe and America. Factories filled with steam-driven machinery were turning out mass-produced goods. Cities were growing rapidly and a network of railways had spread across the countryside. Meanwhile, social mobility increased as people left their villages and headed for the towns in search of work.

With the arrival of new kinds of labour came a more united working class who demanded better treatment and the right to be heard. In 1848, a wave of revolutions spread across Europe, beginning in Paris and reaching the German states, the Austrian Empire, the Kingdom of Hungary, the Italian states, Denmark and Poland. None of these revolutions lasted long and they did not give rise to major political changes, but they did mark a shift in the way people thought about their lives; 1848 became known as the 'year of revolutions' and in the same year Karl Marx wrote the *Communist Manifesto*, urging the workers of the world to unite to gain more power for themselves.

Coinciding with the surge in revolutionary feeling was a growing sense of nationalism. By the 1870s, the new nations of Greece, Italy and Germany had each been formed from a collection of small states. Meanwhile, in America, civil war between the southern and northern states was waged between 1861 and 1865.

The nineteenth century was also a time of empire-building, as France, Britain, and later, Belgium and the newly formed Germany competed with each other to gain control of land in Africa and the Far East. The growth of empires led to an increase in international trade and exotic foreign goods became widely available. Among these imports, Japanese woodblock prints were very popular and their bold, flat colours and asymmetrical compositions had a powerful impact on the young artists of the 1860s. In particular, the landscapes of Hiroshige and Hokusai prompted artists in Europe to view their own landscape in a new way, paying closer attention to its underlying structure and patterns.

Artists were also affected by advances in science and technology at this time. The invention of metal paint tubes in 1840 meant that painters could work out of doors, using tubes of pre-mixed paint, instead of having to mix pigment and oil in their studio. The discovery of photography led to a new interest in realism, and the fast-developing science of optics encouraged painters to experiment with the mixing of colours to create visual effects.

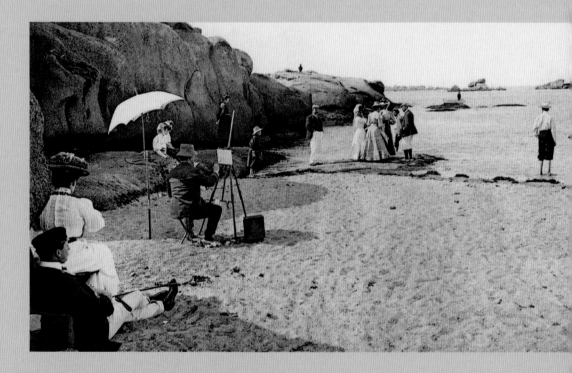

By the 1860s, painting out of doors had become extremely popular. Cézanne was a passionate believer in painting in front of nature, but he chose to concentrate on remote places that were empty of people.

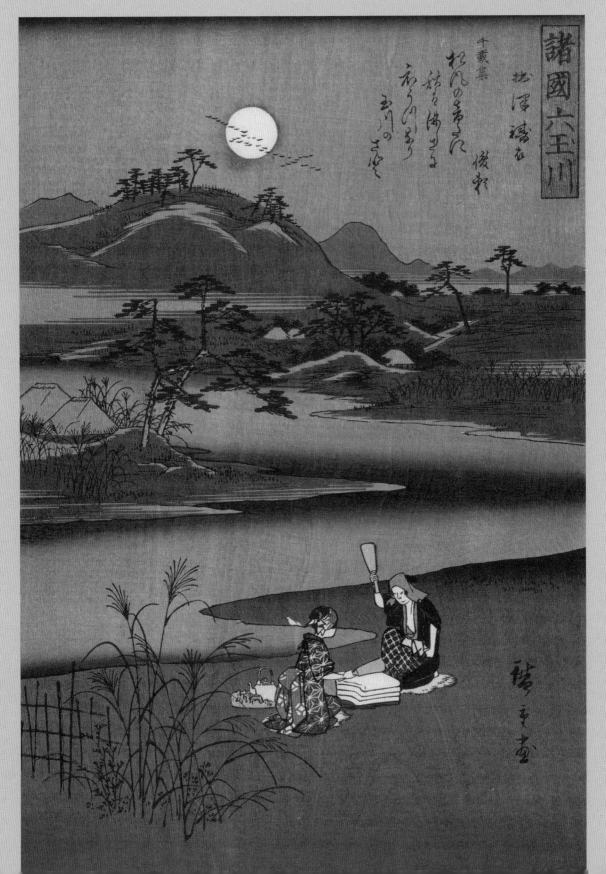

諸國六玉川

千載集

摂津擣衣

松風の音さへ
於て清きに
衣うつなり
玉川の里

俊輔

廣重画

The Kinuta Jewel
River in Settsu
Province, *Utagawa
Hiroshige, 1857.
This print is one
of a series of
river views by the
master printmaker,
Hiroshige. His strong
sense of design and
confident use of
colour were greatly
admired by young
artists in Europe.*

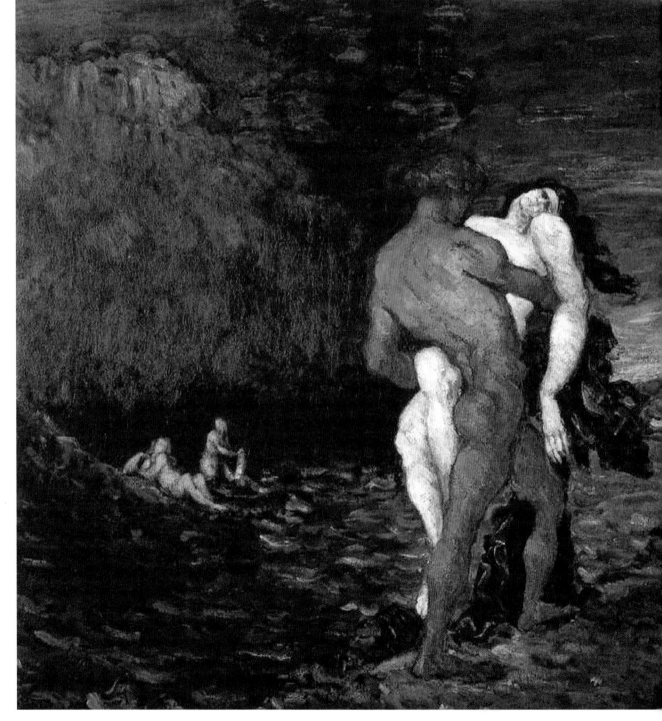

CHAPTER 2
Troubled Times

In early 1858, Zola moved to Paris with his mother, leaving Cézanne stranded in Aix. After five years of intense friendship, he missed Zola desperately and the pair exchanged long letters filled with sad reminiscences about the time that was past. In one letter, Cézanne wrote dispiritedly, 'I don't feel myself, I feel heavy, stupid and slow . . . in the meantime, I lament your absence.'

With his friend gone, Cézanne's studies suffered. The once prize-winning student somehow managed to fail his baccalaureate (the school leaving exam) and had to take it again three months later. At the second attempt he managed a mediocre pass, but it was not an auspicious start to his adult life. To add to his sense of failure, Cézanne learned that Philippe Solari, a friend from primary school, had won a scholarship to study sculpture in Paris, achieving what he could only dream of.

Meanwhile, Louis-Auguste had other plans for his son. In his opinion, Cézanne needed a way to gain money and status and the obvious route to these goals was the law. With no credible alternative to offer, Cézanne agreed to his father's wishes. In September 1858, he joined the University of Provence in Aix and began his training to be a lawyer.

Cézanne's time as a law student did not last long; he registered for just two terms before abandoning his legal studies for good. The obvious next step for an aspiring artist was to move to Paris, where he could learn from other artists and perhaps even find a teacher to nurture his gifts, but Cézanne prevaricated. Part of his problem was the fear that his father would refuse to support him, and letters from Zola also reveal that Cézanne doubted if he had sufficient talent to succeed as an artist.

The Abduction, 1867. *Cézanne gave this painting to Zola, who hid it in his attic because of its risky content. At this time, Zola became increasingly repelled by the gloomy pessimism of Cézanne's work.*

Cézanne's departure was postponed again and again. First, his sister Rose fell ill. Then his father consulted Gilbert, his drawing master, who said he could study art just as well in Aix. Faced with these delays, Zola became impatient. 'Is painting no more to you than a mood that seized you one day when you were bored?' he wrote in desperation. But still his friend failed to make a move.

PARIS AT LAST

Finally, in April 1861, the 22-year-old Cézanne arrived in Paris accompanied by his father and sister Marie, who stayed to see him settled in the capital. In the end, Louis-Auguste had proved to be remarkably supportive, providing his son with a monthly allowance for an open-ended stay. So long as Cézanne was careful with his money, he would have just enough to live on and could devote all his time to art. Cézanne was delighted to be reunited with Zola, although life in the city proved to be challenging to a country boy. Nevertheless, he was determined to stay in Paris and pursue his dream.

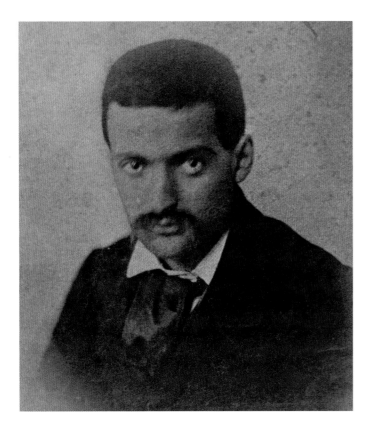

The only surviving photograph of the young Cézanne shows a serious and sensitive young man, with a hint of the defiant spirit that would later become much more evident.

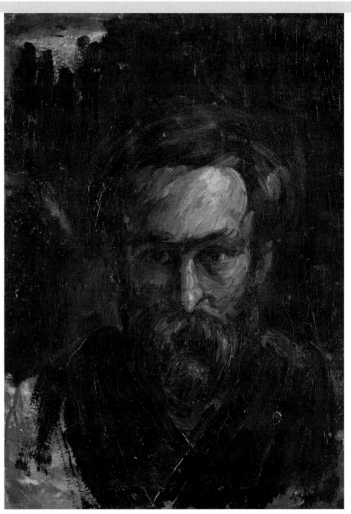

Portrait of the Artist, c.1862–4. One of the earliest of many self-portraits, this study presents Cézanne as a bearded bohemian, but also manages to convey a haunting feeling of self-doubt.

AT THE ACADÉMIE SUISSE

Cézanne's first step in Paris was to enrol as a student at the Académie Suisse. This was a relaxed establishment on the second floor of an old building in the Île de la Cité, founded to give young artists the chance to draw live models. In return for a small monthly payment, students could enjoy three weeks of drawing male models, and a fourth week of drawing females. There were no tutors or classes, and artists of all kinds simply worked together, offering criticism of each other's work. Some notable painters had been students at the Académie, including Delacroix, Courbet and Manet, but at the time Cézanne was there most of the other artists were young unknowns, experimenting in a range of styles.

Cézanne attended the Académie from six until eleven in the morning, concentrating on his figure drawing and painting. Yet despite the relaxed atmosphere in the studio,

This etching of the Avenue de l'Opéra in 1860 shows the impressive scale of Baron Haussmann's elegant streets, allowing for an easy flow of carriages and pedestrians.

PARIS IN THE 1860S

When Cézanne arrived in Paris in 1861, the city was in the throes of a total makeover. In 1853, the Emperor Napoleon III had inaugurated a vast rebuilding scheme under the direction of Georges-Eugène Haussmann. The scheme involved the demolition of many of the old medieval neighbourhoods to make way for a network of wide avenues, parks and squares, flanked by tall buildings in the neoclassical style. It was a drastic solution to a desperate situation. The city's ancient streets had been filthy and overcrowded, providing breeding grounds for cholera and other deadly diseases. In 1845, the social reformer Victor Considerant wrote, 'Paris is an immense workshop of putrefaction, where misery, pestilence and sickness work in concert, where sunlight and air rarely penetrate.'

Haussmann's solution certainly succeeded in bringing more air and light to the city, but at a considerable human cost as thousands were evicted from their homes, retreating to the slums on the edges of the rebuilding works. Socially, too, the city became divided between the rich and elegant Parisians who enjoyed the shops, cafés and theatres and the poor of the city who eked out a living working in shops, factories and brothels.

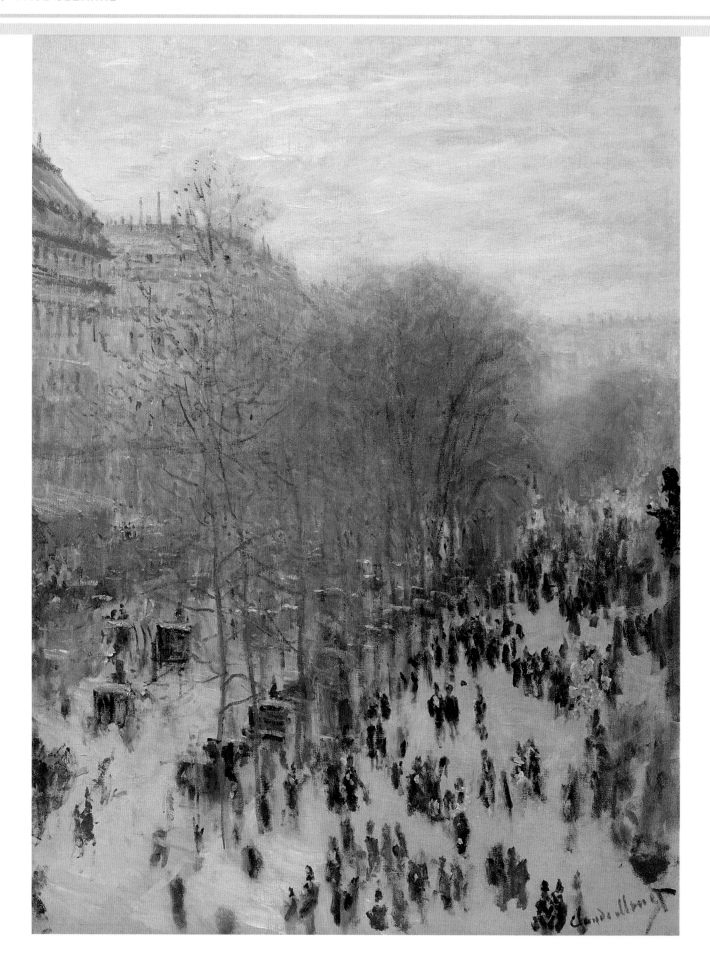

he failed to make many friends. His Provençal manners and accent seemed uncouth to his fellow artists, while his short temper and thin-skinned touchiness earned him the nickname of 'L'Écorché' (or 'flayed man') – a name also given to the plaster models used at the Académie for the study of human muscles.

The 1860s in Paris were years of artistic experiment when young painters such as Edouard Manet and Claude Monet were trying out new styles, but Cézanne chose to retreat from these challenges. Instead, he relied mainly on the friendship of two painters he had known in Aix – Joseph Villevieille and Achille Empéraire. He also spent time with Zola, discussing art and literature and painting his portrait, but discarded three paintings before they were completed.

BANKER OR ARTIST?

Instead of enjoying everything that Paris had to offer, Cézanne found himself missing home, and soon reverted to his habitual mood of self-doubt. As the months went past, Zola felt his friend was avoiding him and he began to despair of Cézanne's lack of drive. Writing to their mutual friend, Baptistin Baille, he complained, 'I need only tell you that the moment he arrived here he talked of returning to Aix. He fought for three years to come here and now he doesn't give a fig for it all . . . I keep my mouth shut and pack away my logic. Trying to persuade Cézanne of something is like trying to get the towers of Notre-Dame to dance a quadrille.'

Zola was right to fear that his friend was losing heart. In the autumn of 1861, just five months after he had arrived in the city, Cézanne packed his bags and headed back to Aix, resigned to taking up his father's offer of a job as a clerk in the bank of Cézanne and Cabassol. However, this resolve turned out to be short-lived. In the end, he toiled in the bank for just four months before abandoning the effort and devoting his time to art. Enrolling once more at Gilbert's school of drawing, he made painting expeditions into the countryside and set up a studio on the top floor of his family's country home, the Jas de Bouffan.

Boulevard des Capucines, Claude Monet, 1873. Monet's painting in the Impressionist style conveys a sense of the grandeur and glamour of the newly rebuilt city of Paris. Monet sometimes worked at the Académie Suisse, along with other artists who would later become known as the Impressionists.

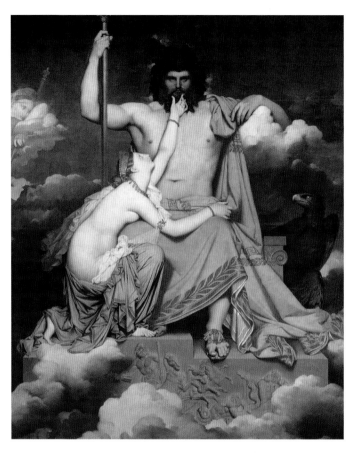

Jupiter and Thetis, *Jean Auguste Dominique Ingres, 1811. This dramatic painting in the Aix museum was the subject of intense study for the young Cézanne. It provided a model for his early figures, with their bright, clear colours, and he may also have been attracted to the painting's strong triangular composition.*

While Louis-Auguste was unsupportive in many ways (he was in the habit of vetting his son's mail and cutting up his canvases in his absence), he did supply Cézanne with a monthly allowance. He also paid for the insertion of a high window in the roof of the Jas de Bouffan to create a light-filled studio and he even allowed his son to decorate the walls of the elegant salon. The salon murals included a landscape and a religious scene, and a set of four tall panels, flanking a full-length portrait of the artist's father (see page 17), which formed the focal point of the room. The four panels showed female figures representing the seasons (see *Spring* and *Autumn* overleaf). Cézanne painted the figures in a classical style, and jokingly signed them 'Ingres' (an artist he greatly admired). At this stage, he still had a long way to travel before he would find his own style.

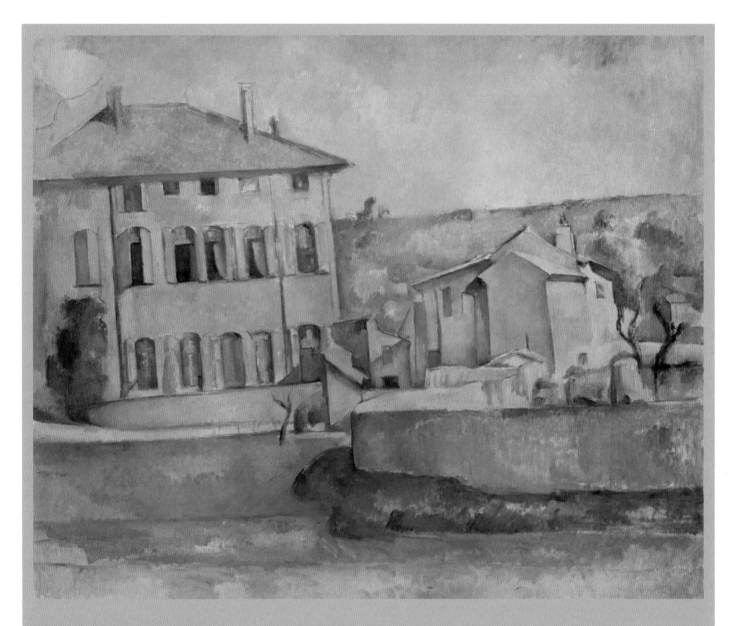

THE JAS DE BOUFFAN

By the time Cézanne reached his late teens, his father was on the lookout for a country retreat that would fit his status as the proprietor of the town's only bank. He found the perfect place in 1859. The Jas de Bouffan was a large, well-proportioned manor house dating from the eighteenth century, which had once belonged to the governor of Provence. Set in a 15 hectare (37 acre) estate, about 3 km (2 miles) west of Aix, it overlooked a picturesque garden with ancient trees. At the time of its purchase it was in a sadly dilapidated state, with most of the rooms locked up and uninhabitable, but patient renovation resulted in an elegant summer residence which would later become the centre of Cézanne's artistic life.

House and Farm at the Jas de Bouffan, *1885–7. The Jas de Bouffan would provide a refuge for Cézanne for 40 years, becoming a constant motif in his art. This painting in his mature style explores the shapes made by its buildings.*

RETURN TO PARIS

By the end of 1862, Cézanne was gathering his nerve to return to Paris, but with no particular plan of action. The obvious route to gaining an artistic education was to apply for a place at L'École nationale supérieure de Beaux-Arts. This was where Ingres and Delacroix had studied and it was generally recognized as the proper training ground for artists. Like many young artists at the Académie Suisse, Cézanne had mocked the instructors at the École, often using the slangy name 'the Bozards' (pronounced in the same way as 'Beaux-Arts' in French), but he also dreamed of being accepted there. It is known that he made two attempts to enter the École, submitting works to the committee for appraisal, but both times he was rejected. Later, he commented, 'I am a primitive, I have a lazy eye. I applied twice to the École but I can't pull it all together: if a head interests me, I make it too big.'

The route to success would not be easy, but Cézanne was determined. By November 1862 he was back in Paris, this time resolved not to fail in his ambition to become a great artist.

REALISM AND REACTION

As Cézanne settled back into life in Paris, he was aware of a growing sense of unrest among his fellow artists. Over the previous decade, a movement known as Realism had been emerging in French painting. The Realists included Gustave Courbet, Camille Corot, Jean-François Millet and Edouard Manet. They reacted against the romantic, narrative style that had dominated French art since the late eighteenth century, aiming instead to portray real people and situations with truth and accuracy. The group had an enthusiastic following among young artists, but by the 1860s they were demanding recognition from the Paris art establishment. In particular, they campaigned for their works to be accepted by the selection jury for the Paris Salon, the annual art exhibition organized by the Académie des Beaux-Arts.

Spring *and* Autumn *from the series* The Four Seasons, *1860–1. Cézanne's personified figures of Spring and Autumn, painted in a classical style, display a love of colour, but give little indication of the remarkable artist he would become.*

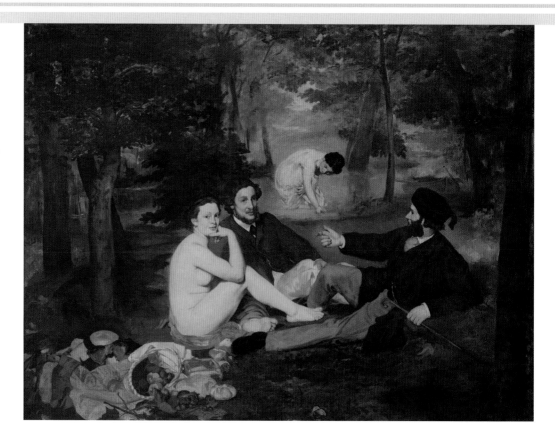

Le Déjeuner sur l'Herbe, *Edouard Manet, 1863. Viewing the Salon des Refusés with Zola, Cézanne was especially impressed by this painting. Manet's clarity and boldness were in sharp contrast to the gloomy mystery of Cézanne's art at this period.*

THE SALON DES REFUSÉS

In 1863, an unusually strict Salon jury rejected around 4,000 paintings, including many works by Realist artists. This prompted a petition to the Emperor Napoleon III, who responded by sanctioning a second exhibition, known as the Salon des Refusés, to show paintings rejected by the Salon. The exhibition was intended to ridicule works that departed from the Second Empire's ideals of beauty, and in part it succeeded. Many works provoked strong reactions of scorn and disgust, with especial outrage directed at Manet's painting *Déjeuner sur l'Herbe* (*Luncheon on the Grass*). But while some visitors came to mock, the Salon des Refusés attracted much larger crowds than the Paris Salon, bringing new artists to the public view.

Cézanne had two paintings in the Salon des Refusés, but these attracted little attention. The subjects of his paintings are now unknown but were probably painted in his dark and troubled early style.

MEETINGS WITH FELLOW ARTISTS

The notoriety of the Salon des Refusés galvanized the young artists of Paris, drawing them together and giving them the confidence to push their work in new directions. Manet and his friends began holding regular meetings on Thursdays and Sundays at the Café Guerbois, on the Avenue de Clichy, where they discussed the future of art. The group of young bohemians became known as the Batignolles (after the district of Paris where they met) and included Frédéric Bazille, Edgar Degas, Claude Monet, Pierre-Auguste Renoir and Alfred Sisley. Émile Zola also took part in the discussions on the future of art and the group was sometimes joined by the older artist Camille Pissarro as well as by Cézanne, although he always remained on the fringes of the group.

Cézanne was still an awkward figure, with his strong Provençal accent, country clothes and distrustful personality, and he made no effort to fit in with the other artists. His usual style of dress was blue dungarees, hitched up high to reveal big lace-up boots, an ancient paint-spattered jacket and a battered straw hat. To this was sometimes added a scarlet sash – a traditional garment of Provence. Monet recalled one occasion at the Café Guerbois when Cézanne proudly raised his jacket to reveal his sash before approaching Manet, removing his hat with a smile and saying, 'I won't offer you my hand, Monsieur Manet, I haven't washed for a week!'

A DARK VISION

Cézanne's art at this period could be just as confrontational as his actions. His paintings, generally executed in sombre colours, depict disturbing subjects and many have a strongly sexual theme. *The Abduction*, painted in 1867 (see page 20), illustrates the classical legend of

The Murder, 1867–70. In this disturbing early painting, the murderers have no faces; Cézanne presents an act of anonymous violence in desolate surroundings. The muddy palette and thickly handled paint help to contribute to a powerful sense of menace.

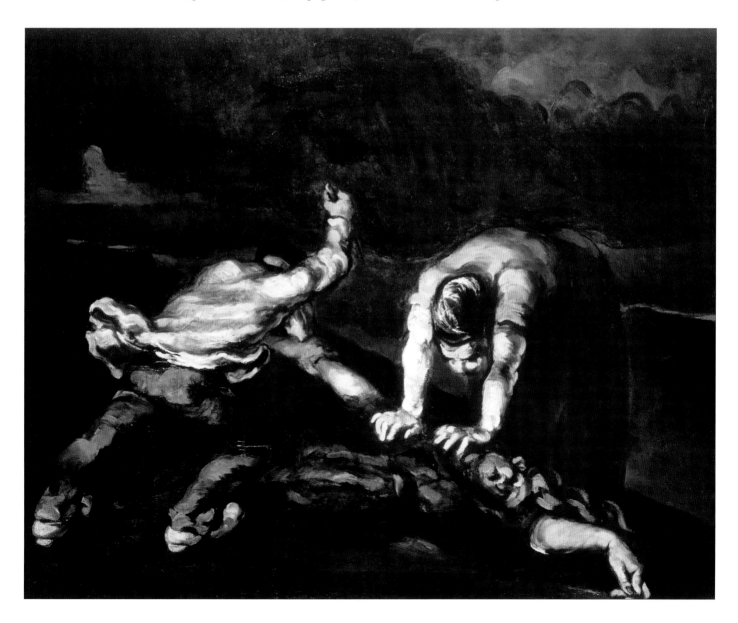

the rape of the goddess Persephone by Pluto, God of the Underworld, shown as a violent conquest of a helpless victim by an aggressive male. *The Murder* (1867–70) depicts a man in the act of stabbing a young woman to death while his female accomplice holds her down and *The Orgy* (*c*.1867) is a riot of bodies and dissipation, revealing, in the view of several critics, a longing for sexual freedom and erotic excess.

Cézanne revelled in the shocking nature of his art, describing his work as 'couillarde' ('ballsy'). Certainly, the paintings make bold statements, but they can also be seen as reflections of the artist's inner turmoil. Critics have interpreted their restless and tormented figures as expressions of Cézanne's struggles with self-doubt, lack of sexual confidence and feelings of hostility towards his controlling father.

OTHER EARLY WORKS

During the 1860s, Cézanne divided his time between Paris and Aix and experimented in a wide range of genres, producing dramatic scenes, flights of erotic fancy, portraits and still life studies.

The Black Marble Clock, c.*1870. In this early still life, Cézanne explores the relationship between strikingly different objects. The dark, heavy clock presents a dramatic contrast with the delicate pink shell and the composition is unified by a set of strong vertical lines.*

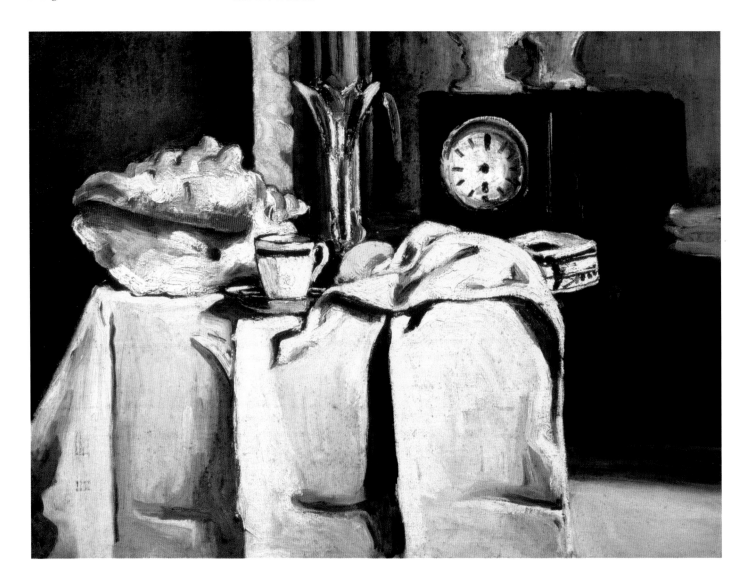

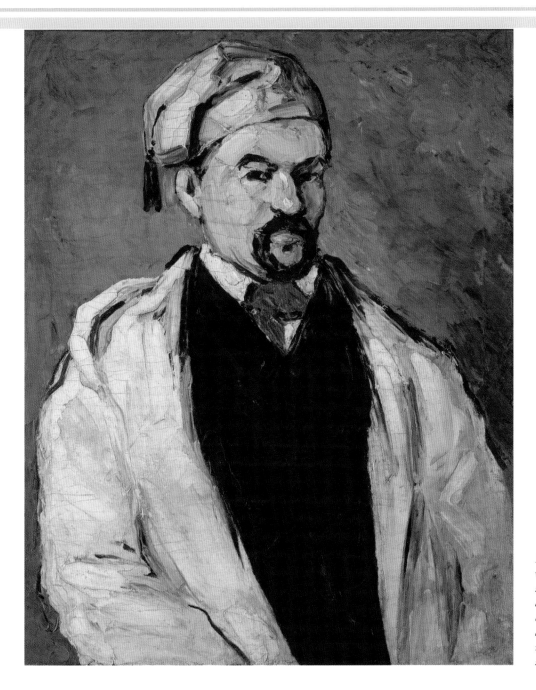

Antoine Dominique Sauveur Aubert,
the Artist's Uncle, *1866. In this
sensitive study, Cézanne makes use of
a limited range of colours to create
dramatic tonal contrasts. The portrait
also reveals his technique of using
repeated brushstrokes to build up the
structure of his subject's face.*

Among his portraits of this period is a sequence painted in Aix, showing his uncle, the
bailiff Dominique Aubert. Uncle Dominique was clearly an obliging sitter as he appears
in various guises, dressed as a lawyer or a monk or wearing a rakish green cotton cap.
Altogether Cézanne made a set of some ten portraits of his uncle: six portrait heads and
four larger, half-length figures. He painted these portraits remarkably fast, using a palette
knife to lay on the paint in bold, thick strokes.

Cézanne also developed his interest in still life, creating some strikingly original
compositions with richly coloured objects starkly outlined against a dark background.
The choice of objects for his still lifes is highly individual. In *The Black Marble Clock*
(*c.*1870), he juxtaposed a cup, a vase and a substantial clock with a lemon and a conch,
creating a distinctive balance of different shapes and textures.

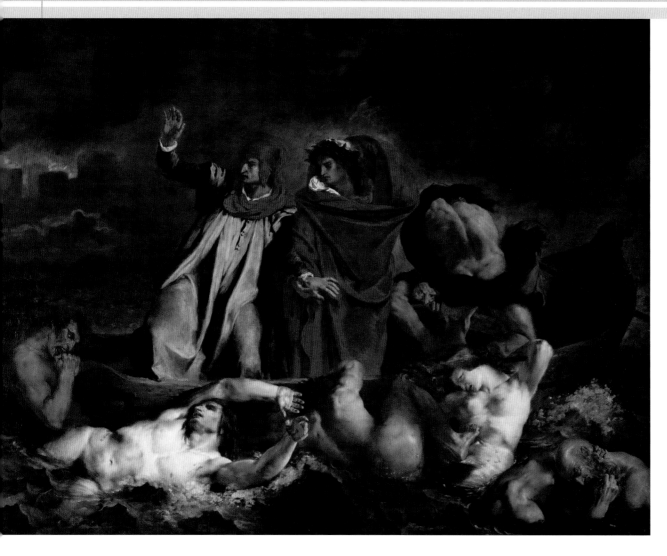

The Barque of Dante, *Eugène Delacroix, 1822. Cézanne made a careful copy of this painting. It is a fine example of Delacroix's mastery of composition as his figures form a dynamic triangle, with a strong focal point in Dante's scarlet cap, and dramatic contrasts between areas of light and dark.*

ARTISTIC INFLUENCES

The young Cézanne made a deliberate attempt to learn from other artists. Ingres was an important early influence, and once Cézanne was living in Paris, he devoted long hours to studying and copying Ingres' work in the Louvre. He was also drawn to the work of the Dutch and Spanish masters of still life, admiring the luminosity of their objects and their rendering of form. Chief among his heroes was Eugène Delacroix; Cézanne made six copies of his works, aiming to emulate the way the master used colour and light to highlight his dynamic figures.

Of his contemporaries, Cézanne admired the sombre realism of Gustave Courbet, copying his use of a palette knife and his dark but dramatic colours. He was also impressed by the clarity and confidence of Edouard Manet's paintings, but his greatest admiration was reserved for the work of Camille Pissarro, the artist who would later become his mentor.

CÉZANNE AND HORTENSE

In 1869, Cézanne met Marie Hortense Fiquet. He was 30 years old, a struggling painter living on a small allowance from his father, while she was 19, a bookbinder and artists' model, living alone in Paris. By the following year, the couple were living together in Cézanne's cramped apartment.

Hortense was originally a country girl. Her father was a farmer in the Jura district (close to the Swiss border), who had moved his family to Paris in search of a better life. Sadly, life in the capital had proved desperately hard for the Fiquet family; first Hortense's sister had died, followed by her mother. After his wife's death, Hortense's father returned to his farm, leaving his 17-year-old daughter to survive alone in Paris. Despite the difficulties of her situation, it appears that Hortense was a respectable girl, with no history of relationships before she met Cézanne. However, she was not well-educated or refined and showed no interest in art or literature, making her perhaps a

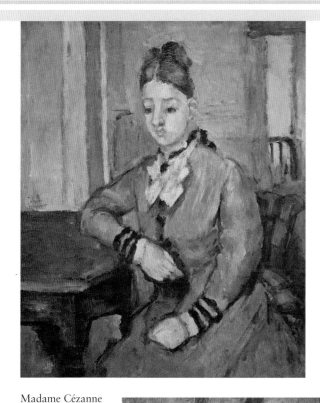

Madame Cézanne Leaning on a Table, *1873–7. Hortense clearly had great reserves of patience, as she sat for over 40 portraits. The portraits reveal a reserved-looking woman with a long, rather melancholy face.*

surprising choice for Cézanne, with his passion for reading and his obsession with art.

Once established in her relationship with Cézanne, Hortense displayed a love of city life, fashion and gossip. In later life, when she had more money to spend, she enjoyed travelling and gambling in casinos. The Cézanne family objected to her greed and vulgarity, viewing her as a gold-digger and giving her the nickname of 'Queen Hortense'. Cézanne once joked that she liked 'only Switzerland and lemonade'.

There must have been some closeness in the couple's early years together, although Cézanne's letters reveal that their relationship failed to bring relief from his constant feelings of loneliness and frustration. Throughout his life, he had a troubled attitude towards women, admitting to feeling panic-stricken in the presence of naked female models.

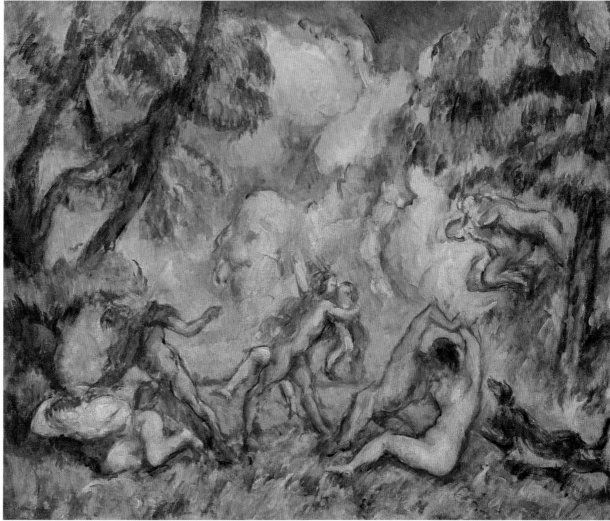

The Struggle of Love, c.1880. *This painting depicts a scene of violent conflict between partners. It has been interpreted as an expression of Cézanne's complex response to relationships.*

CÉZANNE AND MANET

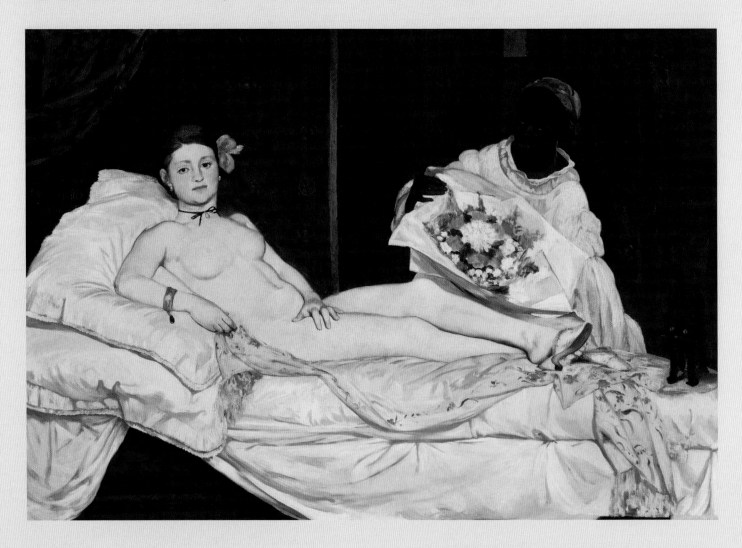

Olympia, 1863, Edouard Manet. Manet's Olympia conveys a sense of clarity, confidence and ease. The composition is enlivened by delicate touches of humour, such as Olympia's cheeky bow and her staring cat.

In his early thirties, Cézanne produced a set of paintings in response to two of Edouard Manet's most famous works: *Olympia* and *Le Déjeuner sur l'Herbe* (see page 28). Both of Manet's pictures had provoked a scandal when they were first exhibited in Paris, and by the 1870s they had become icons of the young and rebellious Impressionist movement.

In *Olympia*, painted in 1863, Manet created a strikingly contemporary interpretation of a well-established classical subject: a naked goddess reclining on a bed, accompanied by a young attendant. Manet shocked Parisian audiences with the overt sexuality of his Olympia, gazing directly at her audience, while a number of details (including

the orchid in her hair, her jewellery, and her slippers) clearly identify her as a prostitute. Cézanne's first artistic response to Manet's painting dates from 1870 when he was 31 years old, and like many of his early 'ballsy' paintings it explores disturbing themes. In Cézanne's painting, Olympia is very evidently a prostitute. She reclines in her boudoir, framed by an elaborate urn and curtain, and a table laden with fruit and drink. Like Manet's Olympia, she is attended by a maid, although Cézanne's attendant is much more sketchily shown. His major change is the introduction of a male spectator. The figure, who may well represent Cézanne, is turning his back on the viewer to gaze at Olympia, adding

A Modern Olympia, 1870. *While Manet's Olympia dominates the scene, boldly holding the onlooker's gaze, Cézanne's Olympia appears to be a passive victim, contained by the oppressive framing of the boudoir and her waiting suitor.*

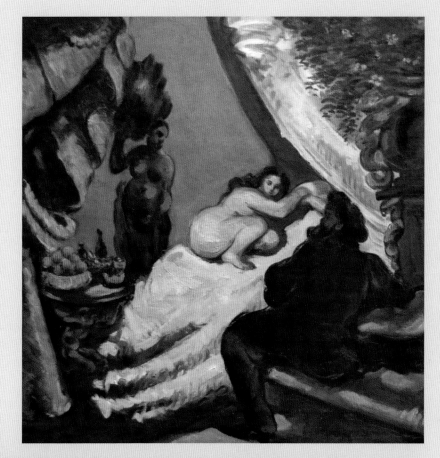

an uncomfortable sense of voyeurism to the scene.

Manet's *Le Déjeuner sur l'Herbe* was shown at the Salon des Refusés in 1863, where it caused a scandal with its bold combination of a naked woman surrounded by formally clothed male figures. Several years later, Cézanne created a deliberate response to Manet's notorious image, also bearing the title *Le Déjeuner sur l'Herbe*. As in Manet's version, the painting shows a group of young people picnicking in a shady woodland, but while Manet used clear colours to depict a scene of pleasure, the mood in Cézanne's painting is dark and ominous and all the characters are fully clothed. Some critics have recognized personal references within the painting. The seated figure with a bald head and heavy beard has been identified as a self-portrait (at this time, Cézanne was balding rapidly). The woman to his right resembles his portraits of his sister Marie and the dark-haired onlooker in the background, with his arms folded and smoking a pipe, may represent Zola. It has been suggested that the painting shows the artist being confronted with some kind of choice, and the departing couple on the left may represent his lost chance of domestic contentment.

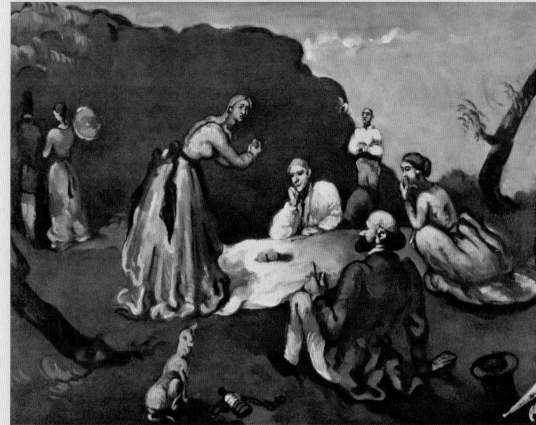

Le Déjeuner sur l'Herbe, c.1870. *Unlike Manet's candid version of this subject (see page 28), Cézanne's scene conveys a disturbing sense of disquiet and discontent.*

WAR AND TURMOIL

The summer of 1870 saw the outbreak of the Franco-Prussian War. This was a conflict between the French Second Republic, led by the Emperor Napoleon III, and an alliance of northern German states, under the leadership of the King of Prussia and his bellicose chancellor, Otto von Bismarck.

The war marked the start of a series of upheavals. After several crushing defeats for the emperor's army, Paris fell first to the Prussians in January 1871, and then to a revolutionary party who set up a government known as the Paris Commune. For the next two months, Paris was ruled by the Commune, until the army of the newly declared French Third Republic managed to seize control of the capital.

By the end of August 1871, peace was finally restored in Paris and Adolphe Thiers was formally elected the first president of the French Third Republic. There was a sense of life in France returning to normal, although strong revolutionary feelings had been stirred up not just in Paris, but throughout the country.

ESCAPE TO L'ESTAQUE

In the face of the growing chaos in Paris, Cézanne and Hortense headed south, and by the summer of 1870, they had settled in l'Estaque, a small fishing village close to the port of Marseille. L'Estaque was just 26 km (16 miles) away from Aix and somehow Cézanne managed to keep his relationship with Hortense a secret from his father, fearing the loss of his precious monthly allowance as well as the weight of his disapproval. It was a deception he was to maintain for the next eight years.

Far removed from danger, Cézanne took no notice of the war, ignoring his call-up papers and concentrating entirely on his painting. He later wrote to the art dealer Ambroise Vollard, 'During the war, I worked a great deal from nature in l'Estaque. Apart from that, I cannot tell you of a single unusual event that occurred in 1870/71. I divided my time between the countryside and the studio.'

There was a brief panic when Cézanne was believed to be on the wanted list for compulsory enrolment in the

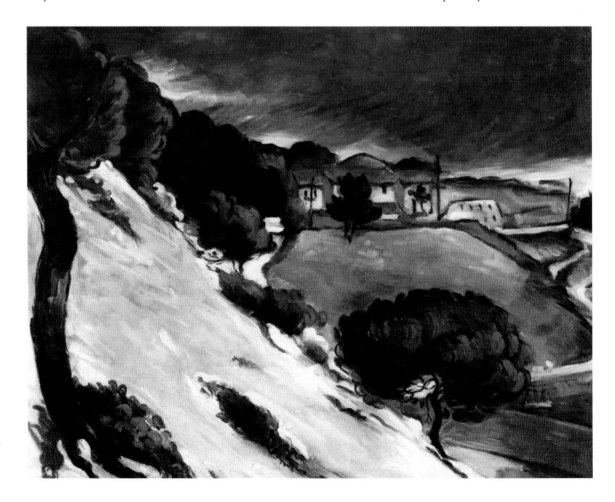

Melting Snow at l'Estaque, c.1870. *In his treatment of this stormy scene, Cézanne conveys the drama of melting snow and darkening sky. Meanwhile, the scarlet roofs draw the viewer's eye into the heart of the picture.*

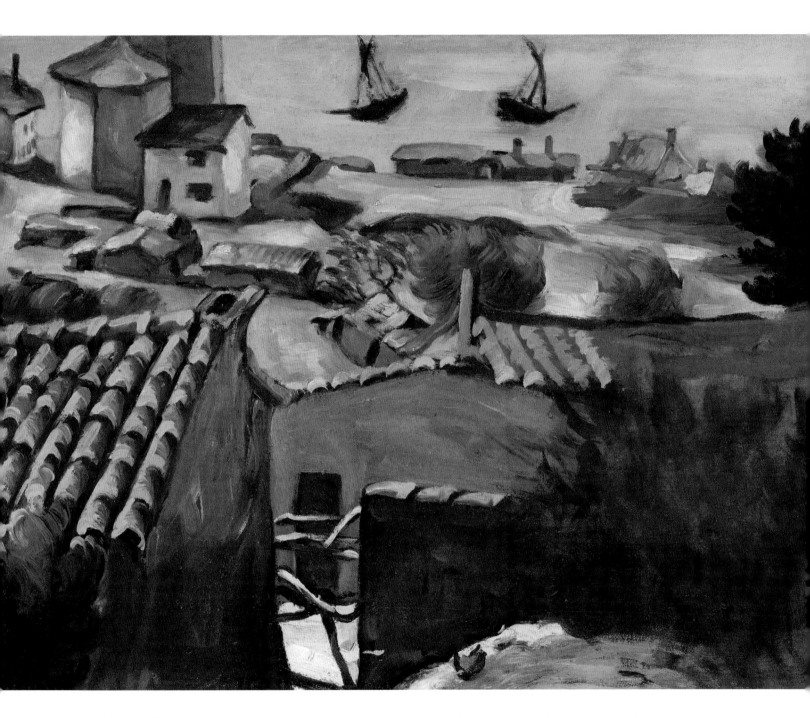

The Fishermen's Village at l'Estaque, c.1870. *Cézanne relished the jumble of simple buildings that made up l'Estaque and experimented with painting the village from many different angles.*

National Guard. The gendarmes were sent to search for him at the Jas de Bouffan, but his mother covered for him loyally, denying any knowledge of his whereabouts and promising to let them know when she heard from him.

The gendarmes never managed to catch up with Cézanne, who remained undisturbed, concentrating on his painting. He was enthralled by the rugged Mediterranean landscape, working out of doors in all weathers and making a great effort to paint exactly what he saw in front of his eyes. The picturesque fishing village of l'Estaque, framed by white limestone crags and emerald green pines, became the subject of a series of paintings which displayed a growing fascination with the patterns made by landscape.

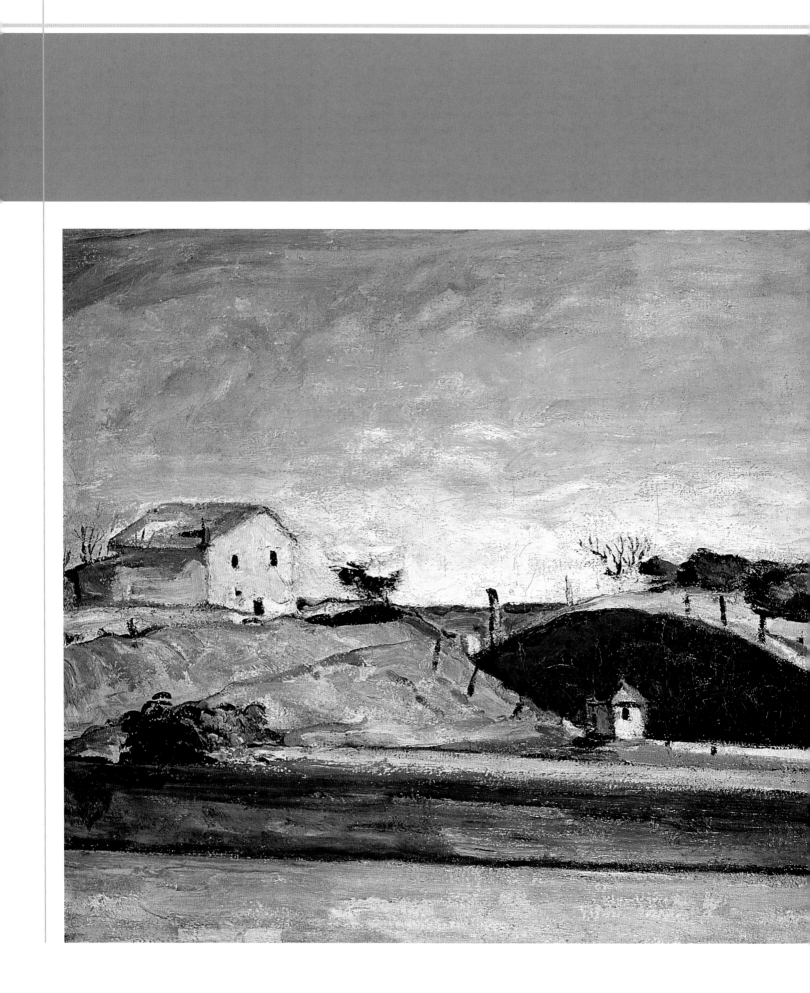

CHAPTER 3
New Directions

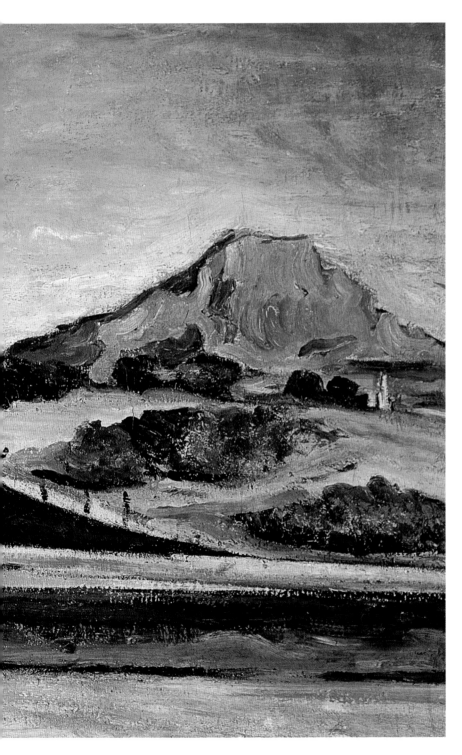

Once the danger of military call-up had died down, Cézanne divided his time between his home with Hortense at l'Estaque and his studio at the Jas de Bouffan, where he concentrated on painting landscapes. Up until this time, the landscape had merely been a backdrop for his scenes, but now it became a subject in its own right.

A key work from this period is *The Railway Cutting*. Painted in light, earth-coloured tones, the picture has a deliberate flatness, displaying Cézanne's interest in the structure and balance of his composition. The three pyramid forms, created by two earth mounds and the taller mountain, have the effect of waves moving across the picture, while the scene is anchored by strong horizontal lines across the base.

Even though *The Railway Cutting* contains no figures, it nevertheless makes a dramatic and tragic appeal, focusing on the wound inflicted on the landscape to allow the passage of a railway. Cézanne felt passionately about the violation of his ancient land by new buildings and railways, once remarking to a painter friend, 'We must hurry – it's all disappearing.'

By the end of 1871, Cézanne and Hortense were back in Paris, and in January 1872, Hortense gave birth to a boy, who was named Paul, after his father. Cézanne doted on his baby son, writing 'Paul is my orient.' But he also felt the strain of having to provide for his family.

The Railway Cutting, c.1870. *In this striking image of the damage that humans can inflict on a landscape, Cézanne shows a small and lonely-looking building starkly outlined against the blood-red wound in the hillside. The mountain on the right-hand side of the painting is Cézanne's beloved Mont Sainte-Victoire.*

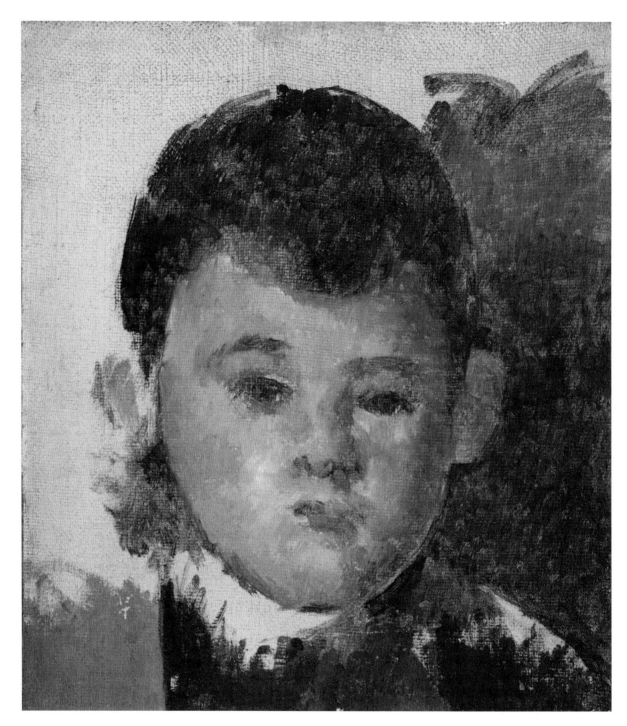

Portrait of Paul,
The Artist's Son,
c.1875. *Cézanne
created many
tender paintings
and drawings
of his son. The
portraits of Paul
as a young boy
are often sketchy
and unfinished
as Cézanne
captured a
fleeting likeness
of his child.*

A GENEROUS INVITATION

The year following Paul's birth was a difficult one for Cézanne, so when Camille Pissarro
invited him and his family to Pontoise, Cézanne gladly agreed.

Cézanne had met Pissarro at the Académie Suisse during his first stay in Paris, and had
been touched and encouraged by his gentle interest. While most of the other artists at the
Académie tended to treat Cézanne as a joke, Pissarro had the wisdom to see his talent.
Cézanne was acutely aware of his lack of a tutor, and in the older and more experienced

artist he recognized a wise and tolerant teacher. Later, he wrote gratefully, 'Pissarro was like a father to me…almost like the good God.'

In 1872, Cézanne and his small family made the move to the city of Pontoise, situated to the northwest of Paris. At first they stayed in a hotel close to Pissarro's home, but by January 1873 they had moved to a house in the nearby village of Auvers-sur-Oise.

Pissarro welcomed Cézanne, reporting in a letter, 'Our friend, Cézanne, raises our expectations… If, as I hope, he stays some time in Auvers, he will astonish a lot of artists who were too hasty in condemning him.'

WORKING WITH PISSARRO

Pissarro was the ideal teacher for Cézanne, working alongside the younger artist and teaching by example. Each day, the pair would go out into the countryside and paint side by side while Pissarro gently shared his perceptions and skills.

The first thing Pissarro did was to encourage Cézanne to banish all dark colours from his paintings. He himself had removed black, ochre and sienna from his palette and he urged Cézanne to follow his example. Pissarro advised him to use just the three primary colours – red, yellow and blue – and create all other colours by mixing them together and adding in some highlights of white. He also urged Cézanne to avoid using lines to outline his forms, showing him instead how to employ varying tones to create a sense of volume, and he encouraged him to build up his picture gradually by using contrasts of light and dark.

Stressing the danger of becoming fixated on a single detail, Pissarro told Cézanne to keep the whole composition in mind and work on applying colour throughout the canvas. Later, Pissarro recorded some of his advice in a letter: 'Work at the same time upon sky, water, branches, ground, keeping everything going on an equal basis and unceasingly rework until you have got it.'

Pissarro also encouraged Cézanne to work with boldness and confidence, and trust in his own judgment. 'Do not be afraid of applying strong colour…Do not follow rules and principles, but paint what you see and feel. Paint boldly and without hesitation, because it's important to get your first impressions down…You must be bold, even at the risk of going wrong and making mistakes.'

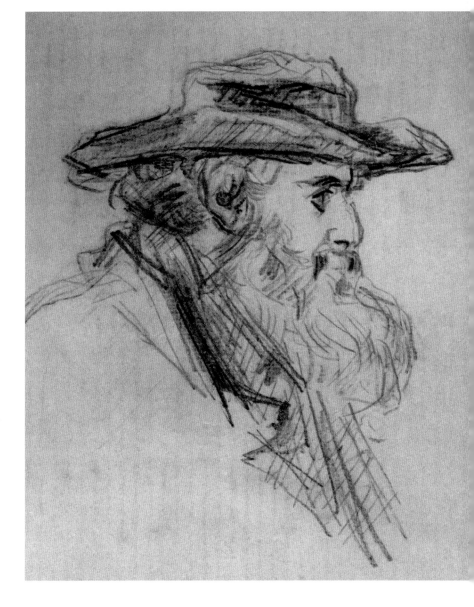

Portrait of Camille Pissarro, c.1873. *This sketch of Pissarro by Cézanne conveys the warmth of his affection for his friend and mentor.*

CAMILLE PISSARRO: A UNIQUE TALENT

Camille Pissarro was born in 1830 on the island of St Thomas in the West Indies. His father was of Portuguese Jewish descent and his mother came from a French Jewish family. When he was 12 years old, he was sent to boarding school in France, where he developed a passion for drawing. Back in St Thomas, he worked as a cargo clerk before deciding to become a full-time artist.

At the age of 21, Pissarro travelled to Venezuela with the Danish artist Fritz Melbye, and stayed there for two years before moving to Paris to begin work as an assistant to Melbye's brother, Anton. In Paris, he was impressed by the Realist paintings of Courbet, Daubigny, Millet and Corot, and eventually he became one of Corot's pupils. Corot encouraged him to work outdoors in front of the scene he was painting, but while Corot completed his landscapes in the studio Pissarro preferred to finish his from life, often at one sitting, in order to give his work a more realistic feel. As a result, his art was sometimes criticized as being 'vulgar' because he painted exactly what he saw. By the 1860s, he had become associated with the group of young artists later known as the Impressionists.

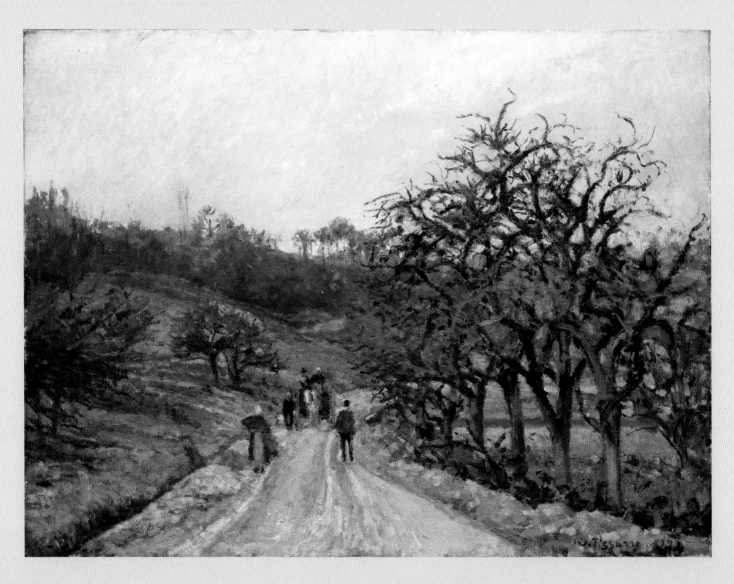

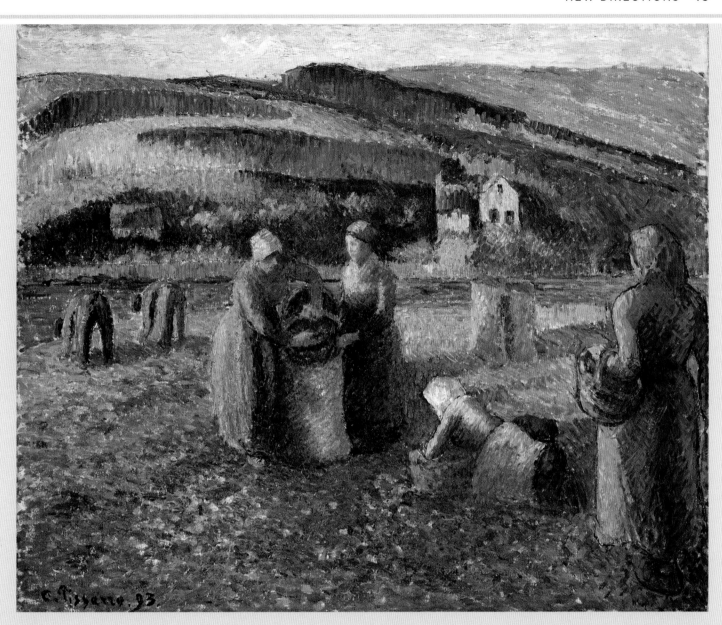

Picking Potatoes, *Camille Pissarro,*
1893. This painting dates from after
Pissarro's pointillist period, but it is
possible to see the impact of this style
on his work. Some of the central areas
of the composition are made up of
thousands of tiny blobs of paint.

Orchard near d'Osny, Pontoise,
Camille Pissarro, 1874. During the
1870s, when Pissarro was painting
with Cézanne, he worked in a soft,
Impressionist style. In this quiet rural
scene, he has made use of subtle
colours to capture the quality of light
in winter. As in most of his landscapes,
country people are featured going
about their everyday lives.

During the Franco-Prussian War, Pissarro left for England, spending two years in London until the war was over. While there, he married Julie Vellay and, following their return to France, the couple went on to have seven children, living first in Pontoise and then in Louveciennes, in northern France. Pissarro became a pivotal member of the Impressionists and was the only artist to show his work at all eight Paris Impressionist exhibitions, from 1874 to 1886.

In the 1880s, Pissarro began to move away from Impressionism and experiment with other styles. He was fascinated by the pointillist techniques developed by Georges Seurat and Paul Signac and spent four years laboriously producing pointillist paintings. Later, he worked with van Gogh and Gauguin, adopting the bold brushstrokes and clear, bright colours typical of the Post-Impressionist style.

Towards the end of his life, Pissarro developed a chronic eye infection which made it very difficult for him to work outdoors except in warm weather. However, he still painted outdoor scenes from the windows of hotel rooms. Right up to his death in 1903 he continued to adapt and develop his art.

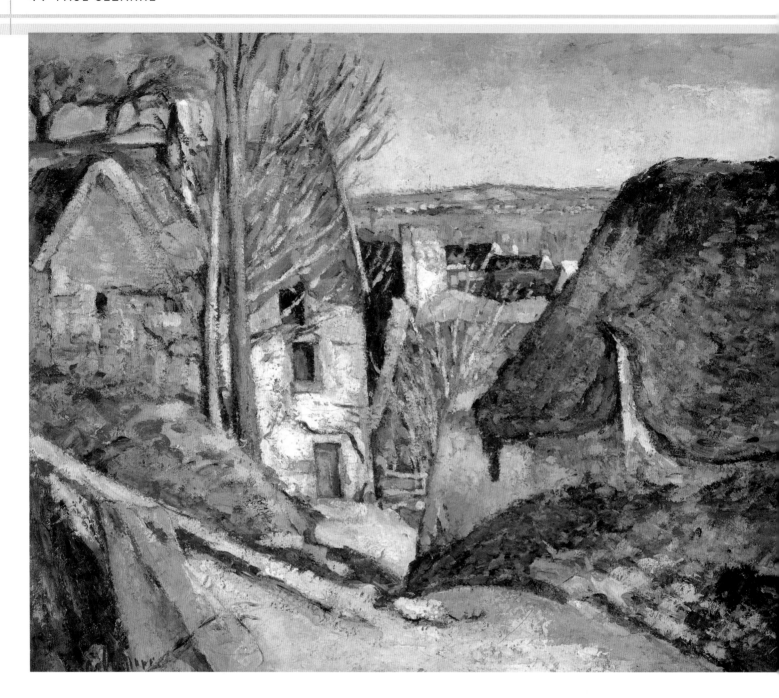

The House of the Hanged Man, c.1873. *The influence of Pissarro can be clearly seen in Cézanne's famous study of a local landmark in Auvers. In this painting, he adopted light, clear colours and made use of gently graduated tones to build up his shapes and forms.*

Perhaps most importantly of all, Pissarro emphasized the importance of careful observation, urging Cézanne to transfer on to the canvas only what he saw. He believed that the artist should be nothing more than an alert and conscientious observer of reality, maintaining that, in the end, 'There is only one teacher; nature.'

A CHANGE OF STYLE

Under Pissarro's kindly care, Cézanne made great progress. He also enjoyed the friendship of Pissarro's large family and would often eat and sleep at their house. The children liked Cézanne and he enjoyed teasing them. He was respectful to Pissarro's wife, always addressing her as 'Madame Pissarro', although he couldn't resist sometimes teasing her too. On one occasion, when she was hosting a dinner for some art collectors

whom she hoped to impress, Cézanne arrived in his paint-spattered work clothes, scratching himself vigorously and saying, 'Don't take any notice, it's only a flea.'

As part of his artistic education, Cézanne undertook an intensive study of Pissarro's work. Soon after arriving in Pontoise, he borrowed one of Pissarro's landscapes and set about the task of copying it faithfully in order to familiarize himself with his friend's

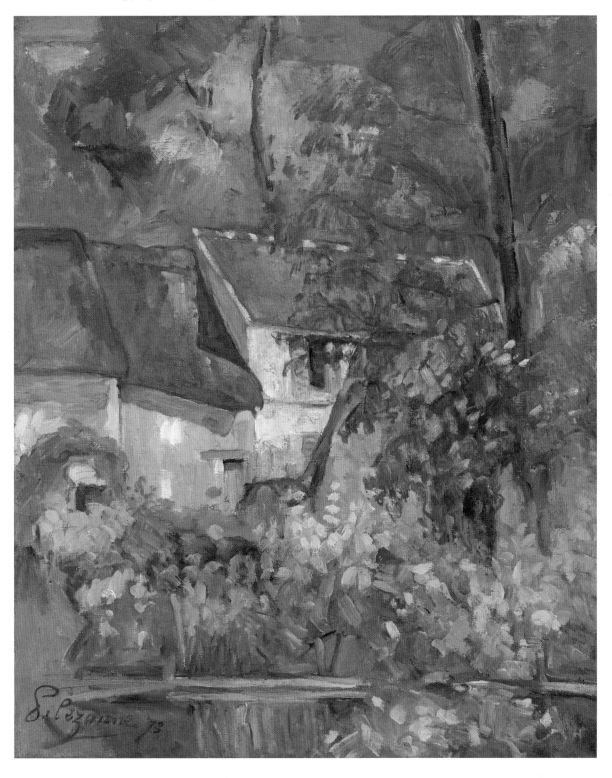

The House of Père Lacroix, *1873.*
This study reveals a growing looseness and confidence in Cézanne's handling of paint, coupled with an enjoyment of vibrant colours.

technique. In Cézanne's copy the brushstrokes are bigger and broader, and this became a key difference in the two artists' styles: Pissarro was a 'dabber' while Cézanne was a 'dauber'. A farmer watching them both at work remarked that Pissarro was 'stabbing the canvas' while Cézanne 'slapped paint onto it'.

The two artists often chose to paint the same subjects, learning from each other as they worked. They would set out together, choose a suitable spot and then set up their easels, Pissarro standing a little in front so that Cézanne could watch him while he remained unobserved. Throughout his life, Cézanne hated to be watched while he worked.

'We were always together,' Pissarro recalled, 'but each of us kept the only thing that matters: our own perceptions.' The two artists remained true to their own visions, developing in different ways. Pissarro liked to pursue ideas of perspective and his landscapes often featured people, while Cézanne's scenes rarely included figures and he was more concerned with the underlying structure of his paintings.

One of the most important skills that Cézanne learned at this time was the ability to slow down in front of a canvas. Before working with Pissarro, he had been in the habit of attacking his canvases with energy and passion, often painting incredibly fast. Under Pissarro's influence, he became more thoughtful and deliberate. Cézanne did not always find it easy to paint with short, patient brushstrokes. However, he felt that these techniques brought him closer to his aim of being true to nature and helped him to banish the sense of violence and turmoil from his work. Indeed, he became so good at taking his time that an observer seeing the two men at work once remarked to Pissarro, 'Your assistant's not exactly straining himself.'

DOCTOR GACHET – PATRON AND FRIEND

When Cézanne moved to the village of Auvers-sur-Oise in early 1873, he found a house close to the home of Doctor Paul Gachet and his family. Gachet was a physician, amateur artist and art lover who would later treat Vincent van Gogh in the last weeks of his life.

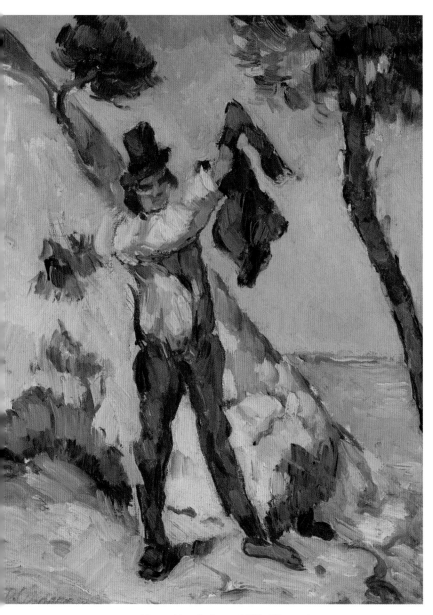

Man with a Jacket, c.1873. *Cézanne's new lightness of touch can be seen in his oil sketch of a 'vagabond' putting on his jacket. Cézanne is clearly revelling in the jaunty air of this disreputable character, with his bare feet, crumpled hat and trousers held up with a scarf.*

He practised medicine in Paris but spent at least three days a week at Auvers, where he lived with his wife and two children in a large house on a hill. Gachet was a larger-than-life character who dressed flamboyantly and dyed his hair yellow, earning himself the nickname of 'Doctor Saffron'. An ardent socialist who refused to charge his poorer patients, he pursued an interest in homeopathy and also followed the new developments in art, becoming friendly with the young artists in the Batignolles group who gathered in the Café Guerbois in Paris.

Gachet welcomed Cézanne into his home and became his first patron, buying a number of his paintings. He took a lively interest in Cézanne's art and encouraged him to take up etching, using the plates and printing press he had installed in his home. In order to please his friend, Cézanne made a few etchings – the only ones he ever produced – and drew

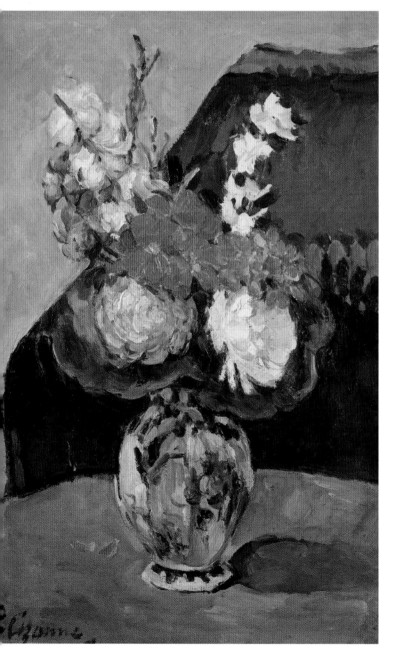

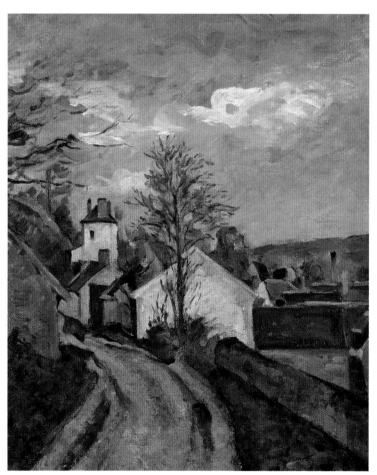

The House of Dr Gachet, 1872–3. *In this tranquil study of his friend's house, Cézanne employs a cool palette of blues, greens and greys and allows the curve of the lane to lead the viewer gently into the painting.*

Flowers in a Small Delft Vase, c.1873. *This is one of a series of still lifes painted in Dr Gachet's studio. Cézanne's use of bold colour contrasts draws the viewer's eye towards the dazzling red at the heart of the painting and to the delicate petals that have fallen on the table.*

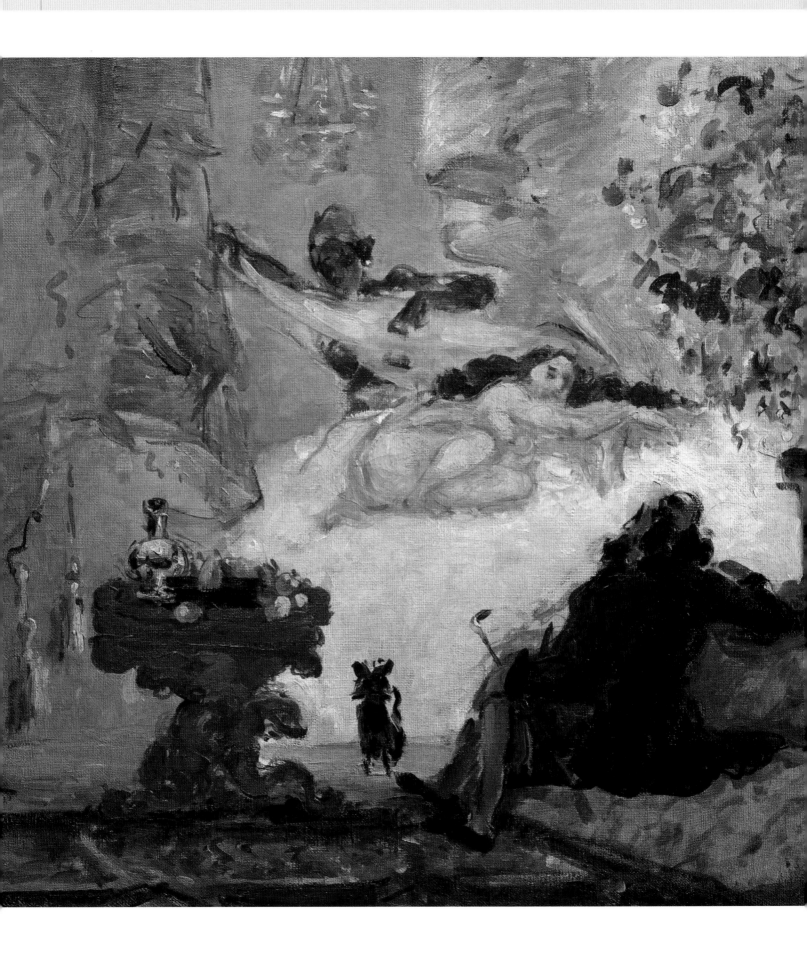

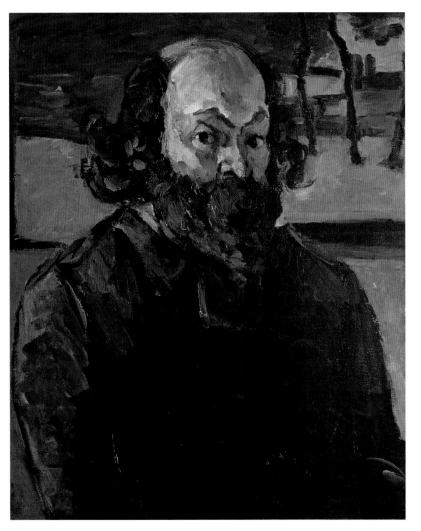

Self-Portrait, c.1873–6. Cézanne began this painting in 1873, the year when he was working closely with Pissarro. Perhaps the most arresting of all his self-portraits, it shows an assertive character, staring straight at the viewer, but with a distinctly haunted, questioning gaze.

A Modern Olympia, 1873–4. This was the one of the paintings that Cézanne submitted to what would later become known as the First Impressionist Exhibition. It was singled out for special invective. One female critic wrote, 'On Sunday the public saw fit to sneer at a fantastic figure that is revealed under an opium sky to a drug addict…this corner of artificial paradise has left even the most courageous gasping for breath. Mr Cézanne merely gives the impression of being a sort of madman who paints in delirium tremens.'

a portrait of Gachet working on an etching, while Gachet in turn made several portraits of Cézanne. Cézanne also used Gachet's studio to paint still lifes. At first, he painted objects without much colour such as bottles, glasses and knives, producing compositions that were predominantly white and grey, but he soon moved on to more colourful subjects, painting the flowers that Madame Gachet picked from her garden. These small canvases blaze with colour – rich blues, reds and yellows – bearing witness to the pleasure he felt at this time in his life.

A SECOND OLYMPIA

One painting that Cézanne produced at this time stands out from his landscapes as a very different kind of composition. It was prompted by a discussion with Doctor Gachet about Manet's *Olympia*. Cézanne had already produced one response to Manet's painting (see pages 34–5) and now he painted a second, once again entitled *A Modern Olympia*. This second painting contains the same elements as the first: the naked woman, her attendant and a male spectator, but it is painted in a much looser style with a brighter palette, clearly demonstrating the radical changes that had occurred in Cézanne's vision and technique.

THE BIRTH OF IMPRESSIONISM

La Grenouillère,
Pierre-Auguste
Renoir, 1869.
In his scene
of Parisians
relaxing by the
river, Renoir uses
short, colourful
brushstrokes to
capture a vivid
impression of
light, colour and
movement.

The techniques that Camille Pissarro shared with Cézanne were very similar to those adopted by other artists at this time. In the summer of 1869, Claude Monet and Pierre-Auguste Renoir had painted a series of scenes at La Grenouillère, a popular bathing place on the banks of the River Seine. The artists worked *en plein air,* in front of their subjects, aiming to capture the lively atmosphere of the riverbank. They experimented with new methods of painting, using strong, bright colours and short, bold brushstrokes to capture fleeting impressions of colour and light.

Monet had met Renoir and two other young artists – Arthur Sisley and Frédéric Bazille – when they were studying with the academic artist Charles Gleyre. The four of them soon discovered that they shared an interest in painting landscapes and contemporary life rather than historical or mythological scenes, and they often headed into the countryside around Paris to paint directly from nature.

In 1874, Monet and his friends organized an exhibition of their paintings in the former studios of the photographer Nadar at 35 Boulevard des Capucines in Paris. Altogether

30 artists took part in the exhibition, including Pissarro and Cézanne, although Manet refused to join them, insisting that the true testing ground for his work was the Paris Salon. The exhibition was not a commercial success and the critics wrote damning reviews. They considered the artists' choice of subjects to be vulgar, claiming that paintings should show historical or classical subjects, not common people going about their everyday lives. They also objected to the Impressionist style, which they condemned as sketchy and unfinished, and they complained about the brightness and lack of subtlety in the artists' palettes. One critic even joked that the artists must have painted their pictures by loading pistols with tubes of paint and firing them at their canvases.

The ridicule had one far-reaching result. One of the paintings exhibited by Monet was entitled *Impression, Sunrise*, and this name was used by the author of a negative review entitled 'The Exhibition of the Impressionists'. The artists tried to reject this label, but it stuck, and helped to draw attention to their radical new approach.

Over the next 20 years the Impressionist movement gained in popularity and influence, as Impressionism spread to other parts of Europe, the USA and Australia. By the late 1880s, however, it was running out of steam, as artists within the original group began to develop in different directions.

Impression, Sunrise, Claude Monet, 1872. Monet's image of sunrise over a river, featuring working boats and cranes, horrified many art lovers, who were disgusted not only by its indistinct colours and forms, but also by the perceived ugliness of its subject.

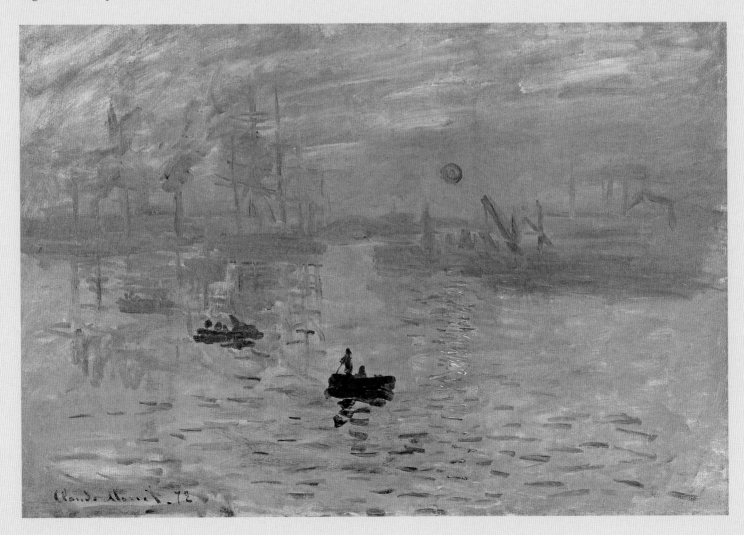

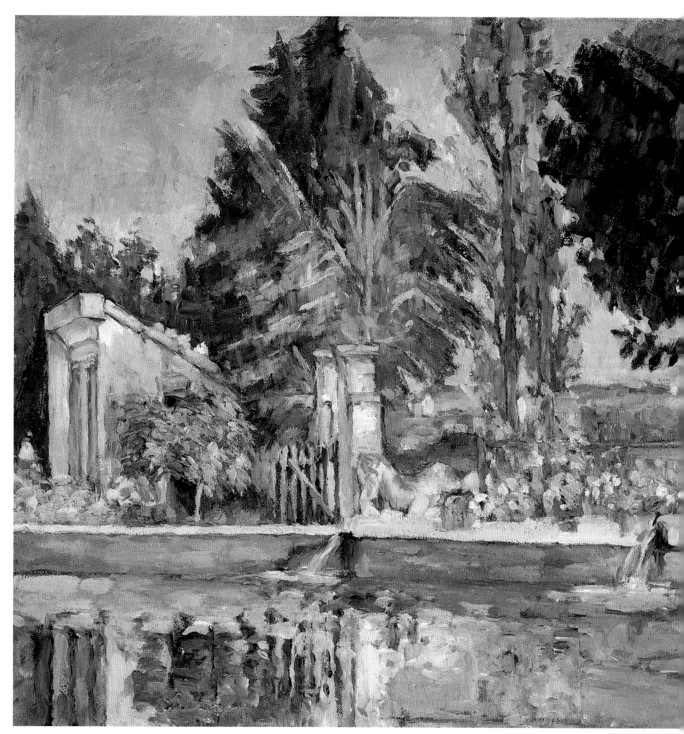

CHAPTER 4
Explorations

In 1874, Cézanne and his family headed south. Once more, Hortense and little Paul lived in l'Estaque, while Cézanne often made the journey from l'Estaque to Aix, where he worked in his studio at the Jas de Bouffan. Cézanne and Pissarro continued to correspond, writing affectionate letters to each other in which they discussed their art and families. Cézanne confided more to Pissarro than to anyone else, describing his feelings of hostility to his father and his tender concern for his son. However, while the friends would work together again for brief spells over the next decade, they never regained the closeness they had enjoyed in the fertile years in Pontoise and Auvers.

Despite the negative reviews of the First Impressionist Exhibition, Cézanne was gaining confidence in his work. Writing to his mother from Paris, he reported that Pissarro 'thinks well of me' and 'I think well of myself' and he continued, 'I begin to find myself superior to those around me.' A few discerning art lovers had also begun to notice Cézanne's talent, and one of his admirers was Victor Choquet.

VICTOR CHOQUET: FRIEND AND COLLECTOR

In 1875, Renoir introduced Cézanne to Victor Choquet, a customs inspector and art collector. Choquet was a passionate art lover who followed his own tastes and had amassed a remarkable collection, including 20 works by Delacroix, as well as paintings by Courbet, Manet and Corot. The collector and the artist developed a warm friendship, cemented by their shared love of Delacroix. It was said that both men had tears in their eyes when they looked at the Delacroix watercolours owned by Choquet, and Cézanne later told Choquet, 'Delacroix acted as an intermediary between you and me.'

The Pool at the Jas de Bouffan, c.1876. *The house and gardens at the Jas de Bouffan provided a refuge for Cézanne, where he could immerse himself in beauty and tranquillity. In this sunlit study of the pool and beyond, Cézanne explores the visual effects of reflections in water.*

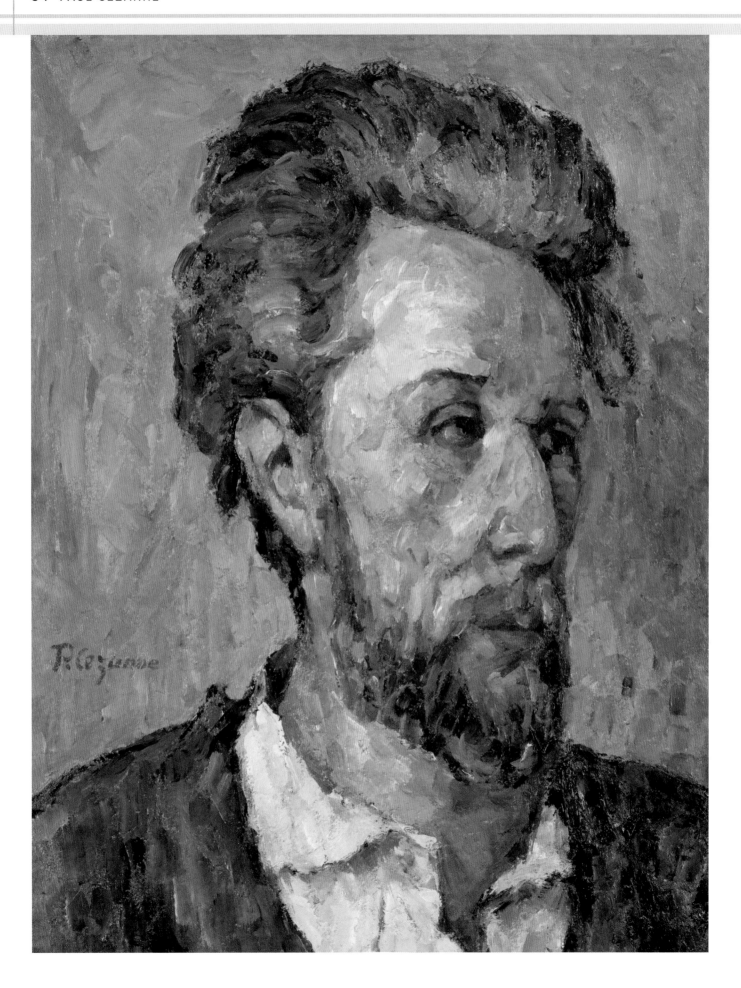

Portrait of Victor Choquet (Head of a Man), *1876–7. One critic described the painting as a study of a man 'whose face – long, long, as if passed through a wringer… is framed by blue hair bristling from the top of his head'.*

Choquet soon became a major collector of Cézanne's work, commissioning many landscapes and sitting for his portrait a total of six times. Cézanne's portraits of Choquet attracted a mixed response. Among his fellow artists, they were widely admired. Degas owned one portrait and wanted to buy another, calling it 'the portrait of one madman by another'. Perhaps the most striking of the six was shown in the Third Impressionist Exhibition with the title *Head of a Man*. It was greeted with ridicule by many and even denounced as 'a work of artistic insanity'.

Over the next 15 years, Choquet acquired a total of 33 Cézannes, becoming one of the very few trusted friends who could commission work directly from the artist. Cézanne even painted two panels for his house in Paris, entitled *The Peacock Basin* and *The Barque and the Bathers*.

One unusual feature of the two men's friendship was that it included their wives. Apart from Zola, most of Cézanne's friends had very little contact with Hortense, who took no obvious interest in art. However, she developed a cordial relationship with Marie Choquet, who welcomed Hortense and her son into her elegant home.

The Apotheosis of Delacroix, *1890–4. Cézanne began working on versions of this tribute to his artistic hero in the 1870s. Set in a Provençal landscape, the painting shows Delacroix ascending to heaven, surrounded by worshippers. On the far right, Pissarro is at his easel, and next to him Monet stands under an umbrella. Cézanne is accompanied by a black dog, and points upwards towards Delacroix. The standing figure on the far left is Victor Choquet.*

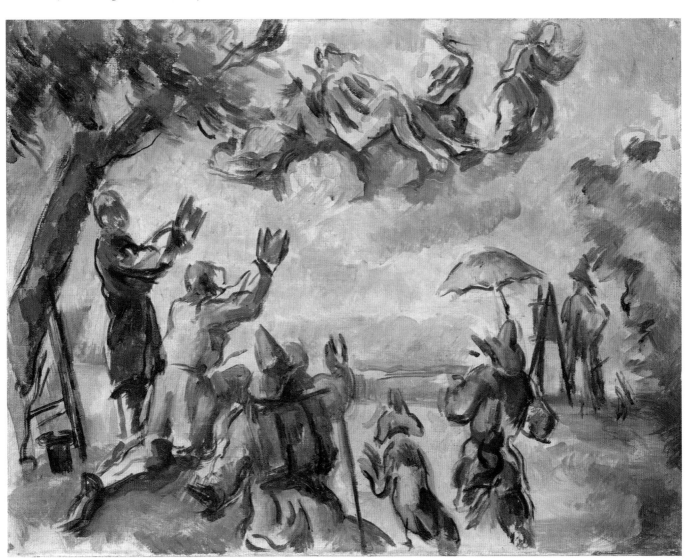

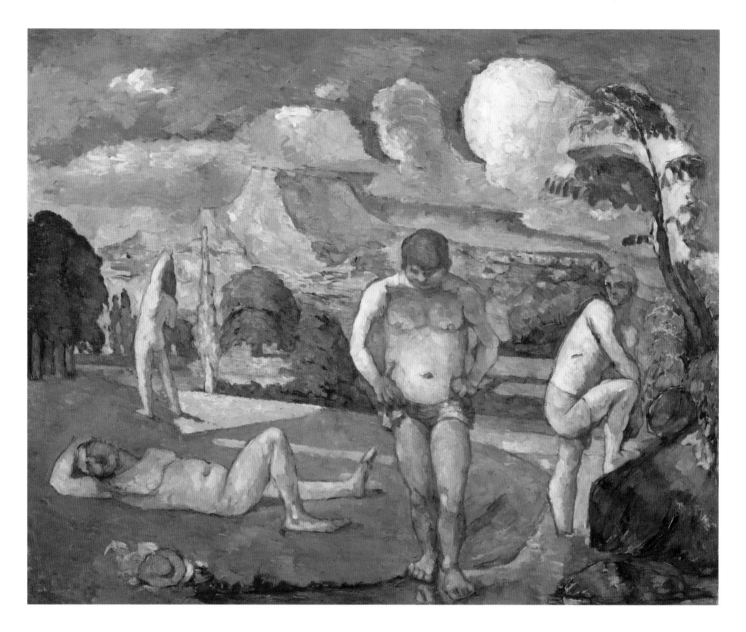

The Bathers at Rest, 1876–7. Victor Choquet was reported to have said, 'I do not know what qualities could be added to this painting to make it more moving, more passionate... The painter of The Bathers belongs to a race of giants.'

THE BATHERS AT REST

Cézanne did not participate in the second exhibition held by the Impressionists, preferring to submit his work to the Paris Salon, even though it was consistently rejected. However, he allowed himself to be persuaded to join in their third showing. The hanging was planned by Renoir, Monet, Pissarro and their artist friend Gustave Caillebotte, who gave Cézanne's work the most prominent position in the main room. Cézanne submitted 14 paintings and three watercolours, including the much-ridiculed portrait of Choquet and a monumental work entitled *The Bathers at Rest*, showing four young men relaxing by a pool in a recognizably Provençal landscape.

While Cézanne's depiction of naked male figures in *The Bathers at Rest* caused outrage, the painting was also widely mocked for its apparently clumsy style. Nevertheless, it attracted some passionate defenders. In particular, the critic Georges Rivière compared Cézanne to the great masters of Ancient Greece: 'In his works, M.

Cézanne is a Greek…his canvases have the calm, heroic serenity of classical paintings and terracotta, and the ignoramuses who laugh in front of *The Bathers*…remind me of barbarians criticizing the Parthenon.' Renoir saw *The Bathers* as an example of Cézanne's 'supremely wise art', while the critic Gustave Geffroy admired the painting's 'ingenious grandeur' and pointed out the Michelangelo-like quality of its figures.

The Bathers at Rest passed through many hands, eventually finding its way into the window of the art dealer Ambroise Vollard, who enjoyed the outrage it attracted among passers-by. In view of the painting's fame, Vollard suggested that Cézanne should create a lithograph based on his composition. Cézanne produced three coloured lithographs, one of which was acquired by the young Pablo Picasso, who kept it in his studio as a source of inspiration.

Dish of Apples, c.1876–7. This richly coloured still life was owned by Victor Choquet. It was painted in the Jas de Bouffan and the decorative screen in the background may have been made by Cézanne in his youth.

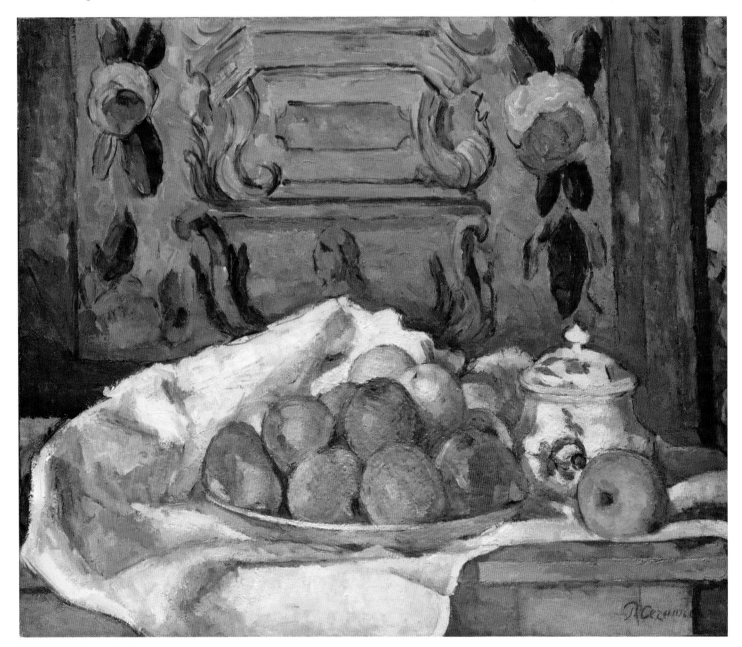

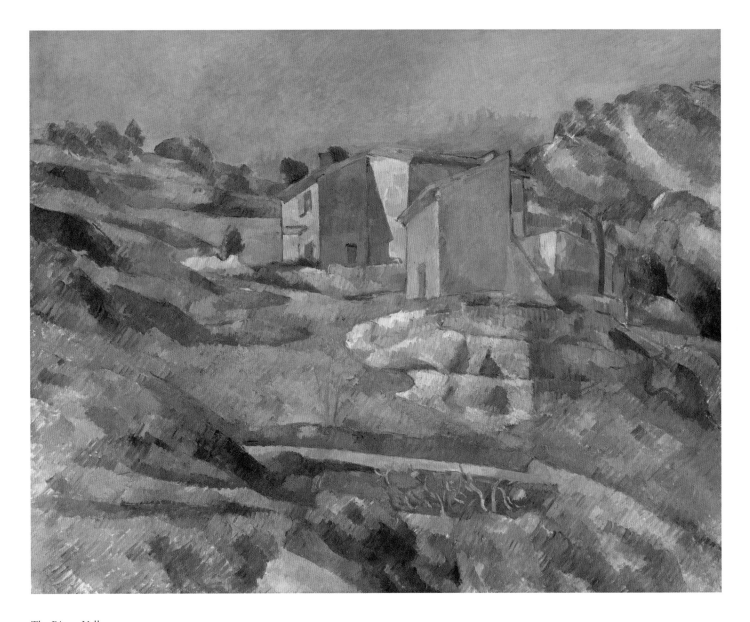

The Riaux Valley near l'Estaque, c.1883. In this painting from the early 1880s, Cézanne is using diagonal 'constructive strokes' to convey depth and structure. His fascination with the effect of strong sunlight is also evident.

A DEVELOPING VISION

The 1870s and 80s were a time of great artistic growth for Cézanne, as he grappled with the challenge of transmitting on to canvas the myriad sensations he received in front of nature. Sometime during the 1870s, he made a technical breakthrough, evolving a method of using small, oblique, parallel touches of colour that he named his 'constructive strokes'. This revolutionary painting technique allowed him to bring order and harmony to what he saw. It also enabled him to move beyond the surface dazzle of Impressionism and show the underlying structure of a scene.

Despite Cézanne's progress and developing confidence in painting, his personal life was strained. Although he was devoted to his son, he found it impossible to live with Hortense, and the couple evolved a way of life in which Cézanne immersed himself in his art, and was often absent from his family, staying with his parents at the Jas de Bouffan. Little is known about the life of Hortense and young Paul at this time, although

Hortense appears to have consoled herself with frequent trips to Paris, sometimes accompanied by her husband. In 1885, however, something happened to alter the balance of this domestic arrangement.

CÉZANNE IN LOVE

In the spring of 1885, the 46-year-old Cézanne had some kind of romantic encounter. The object of his love has never been identified, although some historians have suggested that she may have been Fanny, a young maid at the Jas de Bouffan. What remains is a fragment of a draft of a passionate letter, written in Cézanne's handwriting on the back of one of his paintings. The letter begins 'I saw you, and you let me kiss you, from that moment I have had no peace from profound torment', and continues with an expression of his agonies. It is not known if it was sent, but Cézanne clearly expected some kind of reply when he wrote to Zola, asking him a favour: 'I would be much obliged if you would do me some service, which I think tiny for you and vast for me. It would be to receive some letters for me, and forward them by post to the address that I'll send you later…don't refuse me this service. I don't know where to turn.'

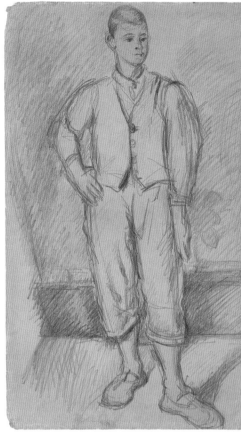

Portrait of the Artist's Son, c.1885. *This sketch of the teenage Paul showing a handsome, self-assured boy probably dates from the period when the family was living in Gardanne (see page 60).*

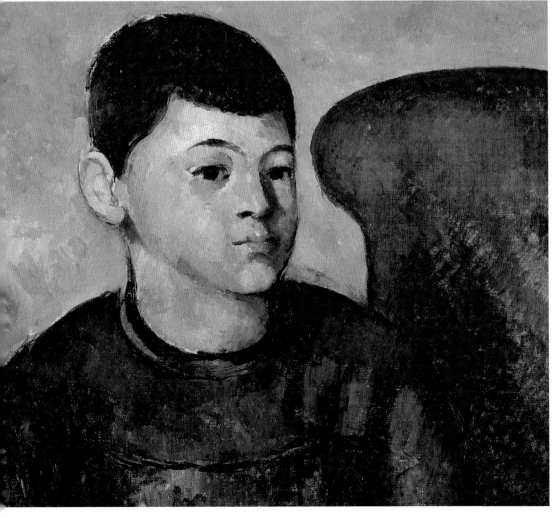

Portrait of the Artist's Son, 1881–2. *Completed when Paul was ten years old, this is the most ambitious of Cézanne's portraits of his son. He uses simplified forms and colours, and the close cropping of both model and chair is similar to framing techniques used in photography.*

It appears from Zola's messages to Cézanne that the expected letters never arrived. For a few months, Cézanne was restless and unsettled, moving from place to place, starting paintings and abandoning them, until eventually he found a new routine. He had discovered a new subject to paint – the picturesque hilltop village of Gardanne, about 13 km (8 miles) from Aix. Basing himself at the Jas de Bouffan, he tramped there and back most days, setting up his easel in different spots to capture the village from all sides.

By the autumn, Cézanne seems to have reached a new resolve about his family. He found a house in Gardanne and Hortense and Paul came to join him. Paul, who was by then 13 years old, attended the village school and in his spare time posed for his father, while Hortense sat for several portraits. Cézanne also made a series of drawings of his wife and son that seem to reveal a new affection.

MARRIAGE AND INHERITANCE

In the spring of 1886 Cézanne and Hortense were finally married in the Town Hall at Aix. The groom's mother and father were among the witnesses to the wedding, while the bride's father was absent but gave his permission for the union. The next day, the marriage was solemnized at the parish church close to the Jas de Bouffan in the presence of Cézanne's sister Marie and his brother-in-law Maxime Conil, husband of his sister Rose.

By the time of the wedding, Louis-Auguste had been aware of his son's family for several years. After nine years of secrecy, the situation had finally come to a head in 1878, when Louis-Auguste opened a letter addressed to his son and learned of 'Madame Cézanne and little Paul.' Enraged at the deception, Louis-Auguste summoned his 39-year-old son to make the 32 km (20 mile) walk from l'Estaque to Aix in order to explain himself. Cézanne was urged to rid himself of his dependants, and his allowance was cut in half.

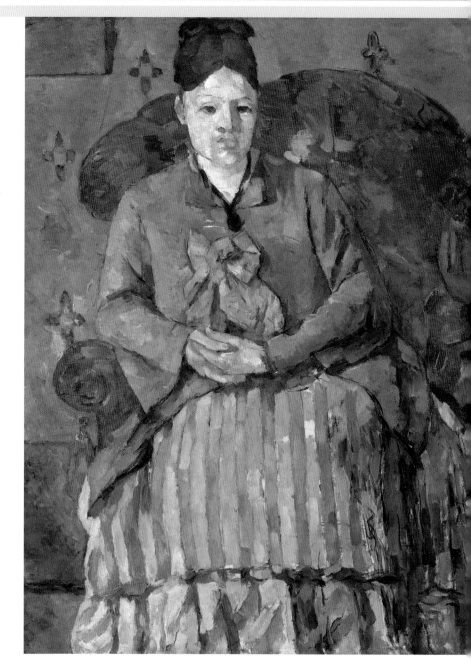

Cézanne's response to this humiliation was to deny having either a mistress or a son, but the evidence kept mounting. A letter for Hortense arrived at the Jas de Bouffan and Cézanne was spotted in Aix buying a wooden rocking horse for Paul. By September 1878, however, it seems that Louis-Auguste had become accustomed to the situation, and his allowance to his son continued as before with occasional more generous gifts.

There are several factors that could have prompted Cézanne's marriage. Both his mother

Madame Cézanne in a Red Armchair, c.1877. This early portrait of Hortense conveys a sense of monumental serenity. Art critics have observed that its many small blocks of subtly varied colour lock together to form a harmonious whole. In one of his most frequently quoted statements, Cézanne said, 'I want to make of Impressionism an art as solid as that of the museums.'

Elisabeth and his sister Marie had long been aware of his secret family and were keen for him to make the relationship legal. Elisabeth wanted her son to be happy and settled and wished to see more of her grandson, while the deeply religious Marie was keen for the couple to be married in the eyes of God. The combination of this pressure and the renewed sense of stability that his family had gained at Gardanne may have combined to persuade Cézanne to take a step that would legalize his family and ensure that they would be provided for in the event of his death.

Six months after the wedding, Louis-Auguste died, leaving the bulk of his estate to his son. Cézanne's money worries were over at last. In retrospect, Cézanne regarded his father with respect, remembering with gratitude his financial support.

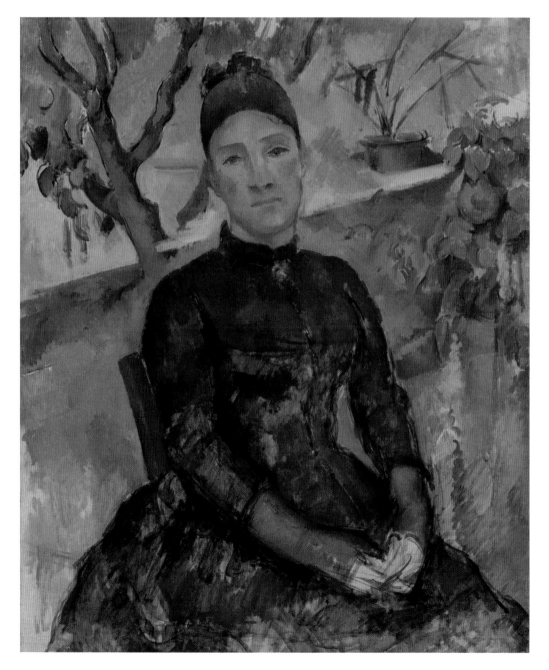

Madame Cézanne in the Conservatory, 1891. Cézanne painted this portrait of his wife in 1891, when he was 52 and she was 41. It differs from the portrait of Hortense in a red armchair in the looseness of its handling, although in both images she appears both impassive and inscrutable.

THE END OF A FRIENDSHIP

In the year of Cézanne's marriage, Émile Zola published the fourteenth book in his cycle of *Rougan-Macquart* novels. The cycle, which would eventually comprise 20 titles, followed the lives of two families (the Rougans and the Macquarts) living in France at the time of the Second Empire. By the 1880s, the novels had gained a devoted readership and were widely admired for their skill. Today, the *Rougan-Macquart* cycle is considered to be one of the leading examples of Naturalism in nineteenth-century French literature.

The fourteenth novel in the cycle, entitled *L'Œuvre* ('*The Masterpiece*'), explores the friendship of two artists: Sandoz, the narrator, who has often been identified with Zola himself, and Claude, his boyhood friend. In the course of the novel Sandoz describes how his old companion, whom he once admired for his outstanding talent, has slowly become alienated from all his friends, as he loses both his brilliance and his mind: '[Sandoz] realized that Claude had somehow lost his foothold and, so far as his art was concerned, was slipping deeper and deeper into madness, heroic madness.' The book charts the tragic decline of Claude, until, in a melodramatic climax, he is found hanging from a noose in front of an unfinished painting.

Many art historians have identified strong similarities between the fictional figure of Claude and Cézanne. Claude is a bearded young

This photograph of Zola holding a camera dates from the last decade of his life. In the years before his death in 1902 he became obsessed with photography, taking thousands of pictures. However, he is best known for his novels, including Nana, Thérèse Raquin *and* Germinal.

Mont Sainte-Victoire and the Big Pine, c.1887. *At the time of his split from Zola, Cézanne was refining his vision of his local landscape. This famous image of Mont Sainte-Victoire has been widely admired for its harmonious composition, with the softly curving branches of the large pine forming the perfect frame for the distant mountain peak.*

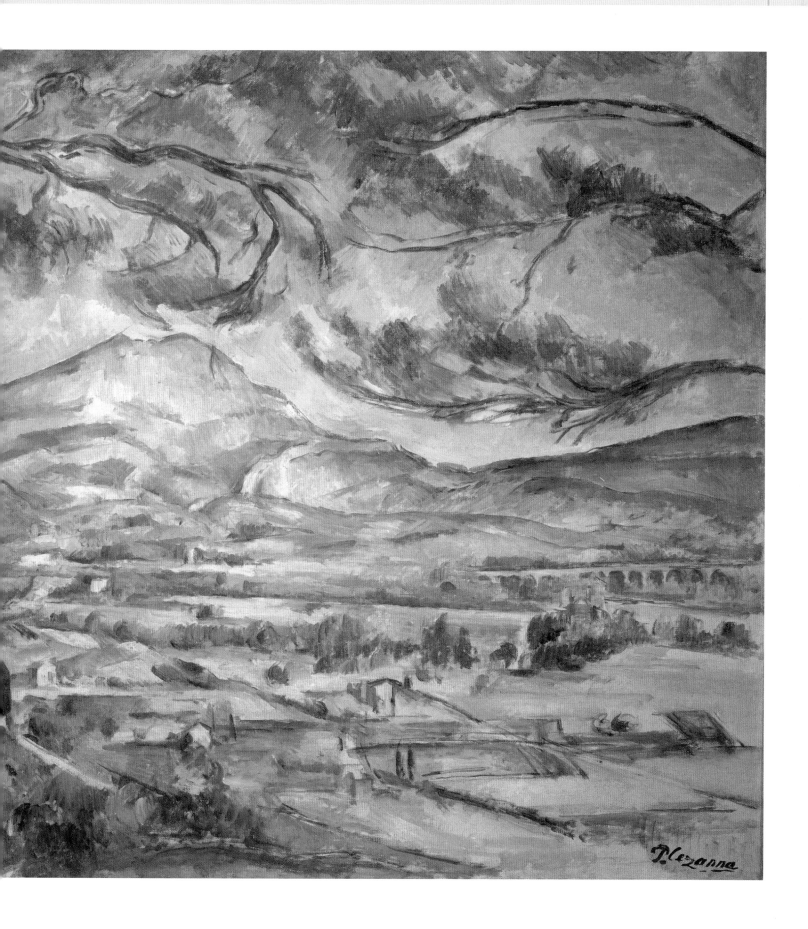

Medea (after Delacroix), c.1880. Zola's depiction of Claude as a tormented artist may have had its roots in his reaction to some of Cézanne's disturbing images. This watercolour version of Medea murdering her child illustrates Cézanne's fascination with the macabre.

man who wears a large black hat and ancient jacket. He has fits of rage in which he destroys his canvases and the oddness of his art is publicly ridiculed. Also, like Cézanne, Claude has a wife and young son.

There seems to be no doubt that Cézanne was one of the models for Zola's creation. At one point in his notes for the novel, Zola even calls his character 'Paul' instead of 'Claude'. However, his portrayal must have also been influenced by other artists he knew. When the book was first published, most of the critics of the day saw Manet as the model for Claude, rather than making any link to Cézanne.

The novel certainly caused a stir among the Impressionists. Monet was deeply troubled by it, writing to Zola to express the fears that 'our enemies in the press and the public will utter the names of Manet or even one of us to make us out to be failures...[and] on the threshold of success, the enemy may make use of your book to crush us.' Pissarro at first dismissed the novel as poorly written, judging the character of Claude to be 'not very well thought-out'. But, after meeting with Monet, he wrote more sternly to Zola, expressing the wish that their friends, including Cézanne, would not 'try to recognize themselves in your heroes, who are so uninteresting, and on top of that, malicious'.

In April 1886, Zola followed his usual custom of sending a copy of his latest book to Cézanne, and his friend wrote a short letter in reply:

My dear Émile

I've just received L'Œuvre, *which you were kind enough to send me. I thank the author of the* Rougon-Macquart *for this kind token of remembrance, and ask him to allow me to wish him well, thinking of years gone by.*

Ever yours with the feeling of time passing,
Paul Cézanne

The letter appears to have been the last communication between the two friends. Yet although the text has been carefully analysed for signs of anger and rejection, there is no obvious evidence that it marked the start of a

permanent rift. The carefully mannered formality is characteristic of many of Cézanne's letters to his friend, and the overwhelming mood of the letter is one of gentle nostalgia for times gone by. Some art historians maintain that Cézanne had not read the book at the time of his reply, although he must have at least been aware of its contents. Over the previous three months, *L'Œuvre* had been serialized in *Gil Blas*, a periodical that Cézanne liked to read, and he had been present when Monet expressed his anxiety about the book.

Perhaps Cézanne read the novel more carefully once it was in his possession, becoming gradually more aware of the closeness between himself and the fictional Claude. But, whatever happened, it was the end of his friendship with Zola. There is no record of them ever meeting again.

Later, Cézanne talked to Ambroise Vollard about his split with Zola, claiming that they had simply grown apart because he did not like the way his old friend lived. 'I no longer felt at ease at his house, with the rugs on the floor, the servants…In the end it made me feel as if I was paying a call on a minister.' However, he also told Vollard, 'I could never get used to the idea that our friendship was a thing of the past.' When, in 1902, Cézanne learnt of Zola's death (of accidental asphyxiation in a hotel room) he was devastated, shutting himself away and howling in grief.

SEARCH FOR PEACE

In the summer of 1890, Hortense managed to persuade her husband to spend five months in Switzerland and the eastern borders of France. By that time their son Paul was 18 years old, but with no career plans, other than providing a chaperone for his mother. For five months, the small family lived in a series of hotels while Cézanne attempted to paint and wrote dejected letters, longing for home.

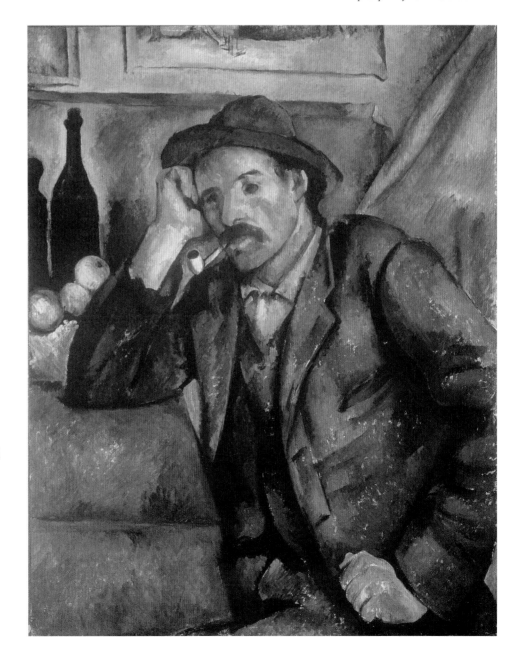

Man Smoking a Pipe, c.*1891*. *As Cézanne grew older, he lost contact with many of his friends, and often turned for company to simple working folk. Here, his empathy for this simple labourer is conveyed through the man's relaxed pose and the warm colours of the painting. The subject's immobility imparts a timeless, tranquil quality to the scene.*

A PASSION FOR STILL LIFE

'I should like to astonish Paris with an apple.'

Paul Cézanne

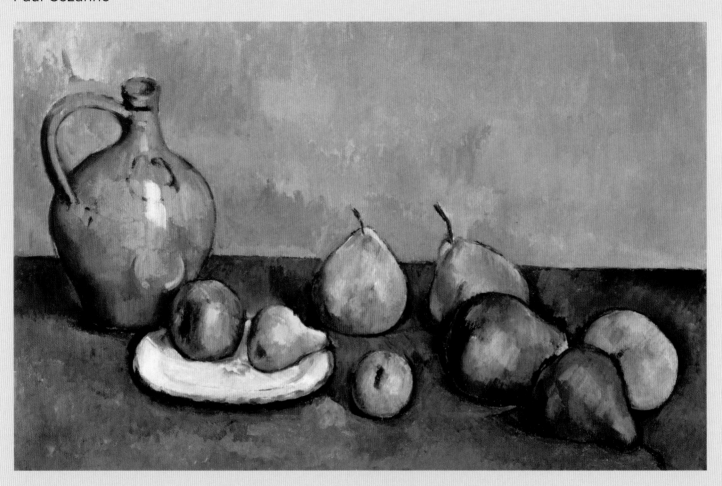

Still Life with Pitcher and Fruit, 1893–4. *In his still lifes, Cézanne aimed to convey the 'personality' of each object, as well as its relationship with the other objects around it. He would sometimes take hours to put down a single stroke because each stroke needed to contain 'the air, the light, the object, the composition, the character, the outline, and the style'.*

From the start of his painting career, Cézanne kept returning to his still-life studies, producing almost 200 surviving paintings. The subjects of these compositions remain remarkably consistent – usually a collection of fruit with some simple household objects, arranged on a cloth. Oranges and apples were favourite subjects; more than a hundred of his still lifes feature the latter. It is evident that he loved the rich colours and basic, geometric shapes of the fruit. He also appreciated the simple craftsmanship that went into the making of ordinary domestic containers such as jugs, jars and bottles.

For Cézanne, the simple, everyday items he chose for his still lifes held just as much significance as grander objects, allowing him to explore the challenge of giving them sculptural weight and volume. He once said, 'I should like to astonish Paris with an apple,' and he aimed to give his still life compositions the same degree of character and animation as any portrait. In pursuit of this aim, he made deliberate use of mixed perspectives, painting his objects from differing viewpoints to create an unnervingly precarious effect.

In order to achieve the effects he wanted, Cézanne took great care to arrange his still life compositions, often propping up fruit and baskets at an angle so that they presented a destabilizing viewpoint. A fascinating account by the artist Émile Bernard describes how Cézanne set up a still life composition for Bernard to work on: 'No sooner was the cloth draped on the table with innate taste than Cézanne set out the peaches in such a way as to make the complementary colors vibrate, grays next to reds, yellows to blues, leaning, tilting, balancing the fruit at the angles he wanted.' Bernard also described how Cézanne adjusted his own compositions, sometimes pushing a coin under a piece of fruit in order to make it tip up at an improbable angle, until he had created a composition that 'delighted his eye'. Yet despite the care with which he set up his objects, once he started painting, Cézanne would continue to adjust the perspectives and tones until they worked in a way that satisfied him.

One of the reasons that still life appealed to Cézanne was that, unlike his human subjects, the objects did not move and could be painted at any time of the day or night, providing the ideal subject for a slow-working artist. The only problem was that, as he usually took so long to complete a painting, the fruit or flowers would wither and die, requiring replacement by paper flowers and artificial fruit. Cézanne would often need more than a hundred sessions to complete a still life to his satisfaction.

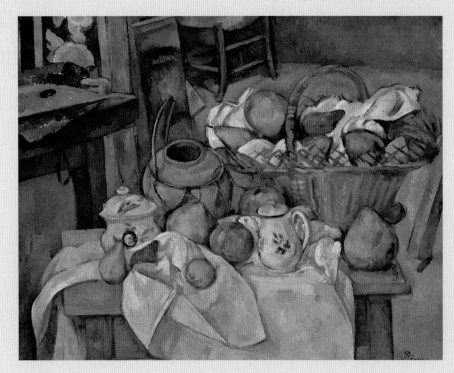

Still Life with Basket, 1888–90. In this vibrant composition, Cézanne experiments with conflicting perspectives; the apples and pots on the small table are seen from above, while the fruit in the basket is viewed straight on. This visual conflict gives the composition an internal energy as viewers are constantly required to shift their gaze.

Still Life with Apples and a Pot of Primroses, c.1890. Colour was a vital component in Cézanne's still lifes, as he exploited the contrasts between the white cloth and the colourful fruit and the varying tones, highlights and shadows in his compositions.

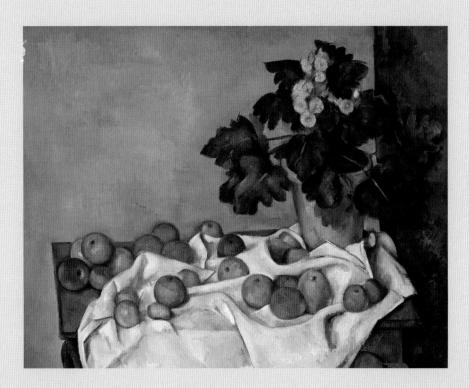

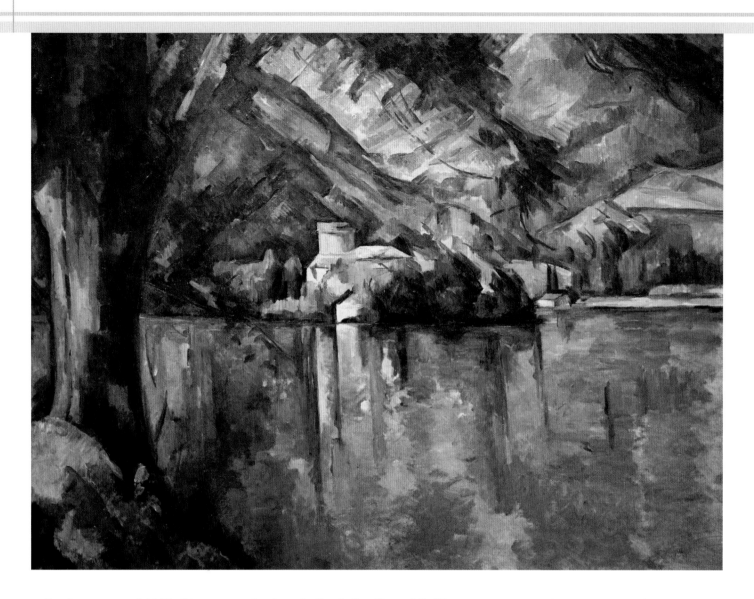

By the autumn of 1890, Cézanne was back at the Jas de Bouffan, while Hortense and Paul had set off for Paris. Increasingly worried about his wife's expensive lifestyle, he finally took action, cutting Hortense's allowance in half and obliging her to spend most of her time in Aix. However, this move did little to improve his emotional state. One of Cézanne's old friends from Aix, the artist Numa Coste, described the strained atmosphere in the family home, writing, 'He lives at Jas de Bouffan with his mother, who…is on bad terms with the Ball [Hortense], who in turn does not get on with her sister-in-law [Marie], nor they among themselves. So that Paul lives on one side, his wife on the other.'

Meanwhile, Coste reported, Cézanne persevered with his art despite these emotional difficulties. He often worked in the garden at the Jas de Bouffan, observing the changes made by different seasons. When in his studio, he concentrated on portraits and still lifes. During the 1890s, he produced many studies of fruit and flowers and a series of portraits featuring Hortense, Paul and some local characters. A peasant woman was portrayed as a cook, while her son was shown seated at a table with a skull in front of him. Day-labourers at the Jas became the models for a series of paintings of card players and men smoking clay pipes.

Lake Annecy, 1896. This painting was made while Cézanne accompanied Hortense and Paul on a holiday for the good of his wife's health. The family stayed in a small hotel and Cézanne, missing his native Provence, pined for 'real scenery'. The painting seems to express the artist's isolation and loneliness in its cold blues and greens.

MEETINGS AT GIVERNY

In 1894, Cézanne travelled to Giverny, the small Normandy village where Claude Monet had created his beautiful home and garden. He arranged to stay at a nearby inn so he could concentrate on his landscape painting, but Monet seized the opportunity to hold a lunch party and introduce Cézanne to some of his friends. Monet's guests included the art critic Gustave Geffroy, who had written very favourable reviews of Cézanne's work, the radical politician Georges Clemenceau, later to become prime minister of France, and the sculptor Auguste Rodin, who had been granted the award of Legion d'honneur in recognition of his artistic achievements. In the days leading up to the party, Monet wrote anxiously to Geffroy, 'I hope that Cézanne… will join us, but he is so peculiar and so fearful of seeing new faces that I am afraid he may let us down, despite his wish to meet you. What a pity that this man has not had more support in his life! He is a true artist who suffers too much self-doubt. He needs to be cheered up.'

In the event, Cézanne did not let Monet down. Instead, he was deeply moved by the honour of meeting Rodin and enjoyed the company of Geffroy and Clemenceau, laughing and joking in an unusually relaxed manner. Later, Geffroy reported on the meeting, 'He struck us all immediately as a peculiar character, timid and ebullient, emotional in the extreme.' Geffroy described how Cézanne took him aside to tell him, with tears in his eyes, 'He's not proud, Monsieur Rodin, he shook my hand! A decorated man!' Later that afternoon, Geffroy recalled, Cézanne knelt before Rodin to thank him again for shaking his hand. Geffroy also noted that Cézanne was especially relaxed with Clemenceau, although he did tell Geffroy on another occasion that he could not support the statesman, giving the odd explanation, 'It's because I'm too weak! And Clemenceau could not protect me!'

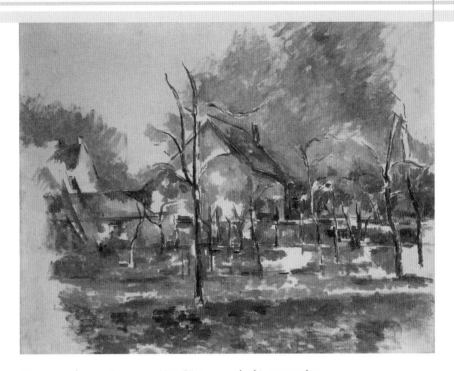

Winter Landscape, Giverny, 1894. *Cézanne made this watercolour sketch of the village of Giverny while staying near Monet's house. In his watercolours, he often left areas of the paper white to allow his patches of colour some 'breathing room'.*

Garden at Giverny, 1895, Claude Monet. *Monet's house and gardens at Giverny provided a tranquil refuge where he could paint and entertain friends. A welcoming host, Monet showed consistent kindness to Cézanne and patiently accepted his changes of mood.*

Cézanne's unusual manners made a strong impression on Matilda Lewis, an American painter who was staying at Giverny. Lewis wrote to her family describing his alarming appearance with 'large red eyeballs standing out from his head in a most ferocious manner, a rather fierce-looking pointed beard, quite grey, and an excited way of talking that positively made the dishes rattle'. She also commented on the artist's uncouth table manners, scraping his soup plate loudly, taking his meat in his fingers to pull flesh from the bone and waving his knife around wildly as he spoke. Yet, despite his total disregard for manners, she recognized that Cézanne showed 'a politeness towards us which no other man here would have shown'. She also described how he insisted that the ladies should be served before him, in defiance of the usual custom, and even showed deference to the household's maid by lifting his hat to her when she entered the room. In short, she decided that this contradictory character actually possessed 'the gentlest nature possible'.

Perhaps encouraged by the success of his lunch party, Monet invited Cézanne to another occasion at his home. This time, Renoir, Sisley and other Impressionist painters were gathered for a banquet of friends. Monet gave a speech in which he told Cézanne how fond they all were of him and how much they admired his art. However, this warm-hearted tribute did not produce the reaction he had hoped. Instead of being delighted, Cézanne seized his coat and headed for the door, saying 'You too, are making fun of me!' Soon afterwards, he left Giverny for good, leaving several unfinished canvases behind him.

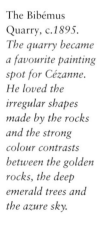

The Bibémus Quarry, c.1895. The quarry became a favourite painting spot for Cézanne. He loved the irregular shapes made by the rocks and the strong colour contrasts between the golden rocks, the deep emerald trees and the azure sky.

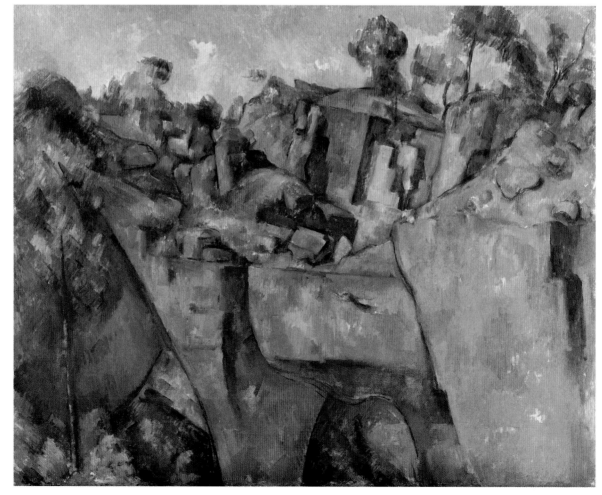

SEEKING SOLITUDE

Although the Jas de Bouffan and its surroundings provided Cézanne with endless inspiration, the strained atmosphere in the house often compelled him to find other places to paint. In 1895, he rented a small, two-storey stone shack above the abandoned Bibémus Quarries. This was a spectacular spot close to the Zola dam (named after Émile Zola's engineer father), and a favourite childhood meeting place for Cézanne and his young friends. Using the shack as a base, he spent long days painting the orange-coloured rocks and contrasting greens and greys of the bushes and pines, all dominated by the rising bulk of Mont Sainte-Victoire.

By this time, Cézanne was in his mid-fifties, still physically strong and able to walk for many miles each day with his painting equipment on his back. However, he had begun to suffer from diabetes. Insulin treatment was not introduced until the 1920s and the main treatment for diabetes available to Cézanne was a severely restricted diet coupled with massage to help the circulation. A feeling of increased vulnerability may have been one of the factors that pushed him towards the solace of religion, with the encouragement of his devout sister Marie. From the 1890s onward, he became a regular attender at mass in the Cathedral of Saint-Saveur.

VISITS TO PARIS

While Cézanne craved solitude, he was also a restless soul, and during the 1890s he made numerous trips to Paris, sometimes in the company of Hortense and Paul. He spent many hours in the Louvre, copying ancient and modern sculpture and making sketches from paintings by Rubens and Poussin. Unlike most of the Impressionists, he never painted city scenes, but instead made occasional painting trips to the forest of Fontainebleau, where Corot and the Realists had pioneered *plein air* painting. He also embarked on some portraits, although progress on these was painfully slow. In 1895, he began a portrait of Gustave Geffroy at home in his library, but after three months of working on it daily he suddenly sent a note asking for his paints and easel to be returned, explaining that the undertaking was too much for him. After much persuasion from Geffroy, he finally returned for one more week's work before leaving for Aix, declaring that he no longer had any faith in his portrait. Cézanne's portrait of his art dealer, Ambroise Vollard, was a similarly

Portrait of Ambroise Vollard, 1899. *Vollard wrote a fascinating description of having his portrait painted. At one point, he remembered, he dared to point out two bare patches on the hands where the canvas had not yet been painted. Cézanne responded: 'Maybe I shall find the right shade tomorrow to paint the bare patches [but] if I were to put any random colour there I would be compelled to overpaint my entire picture from that spot.'*

agonizing undertaking. In 1899, after many marathon sittings that took place during an intensive period lasting several weeks, he suddenly abandoned the project. However, he was persuaded to resume work on the portrait after an absence in Aix.

The months spent in Paris could have been a chance for Cézanne to reconnect with other artists, but instead he took pains to avoid his former companions. Monet described an incident when Cézanne deliberately plunged away from him into the crowds. On another occasion, the artist Paul Signac was walking with Armand Guillamin, a companion of Cézanne's from his early days in Paris, when they spotted the artist coming towards them. As they prepared to greet him, they were stopped in their tracks by his frantic gestures, conveying the clear message that they should walk on by and ignore their old friend.

PAINTING PORTRAITS

Unlike most of his contemporaries, Cézanne never received a portrait commission. Instead, all his portraits were of people he knew. His wife Hortense was a frequent sitter for both paintings and drawings, and he made many tender studies of his son as a young boy, often showing him asleep. He also painted some portraits of artist friends and collectors of his work, but he generally chose working people as his models, preferring the character he found in their time-worn faces. 'What I like most of all is the look of people who have grown old without drastically changing their habits, who obey the rules of time,' he once explained. In his portraits of ordinary people, such as the gardener Vallier, his final model, Cézanne conveys a gentle sympathy for his sitter which illuminates his work.

The Card Players, *1890–5. Here Cézanne creates a quiet drama between the two characters, while the composition is unified by its subtle palette of oranges, browns and greens and its strong horizontals and verticals.*

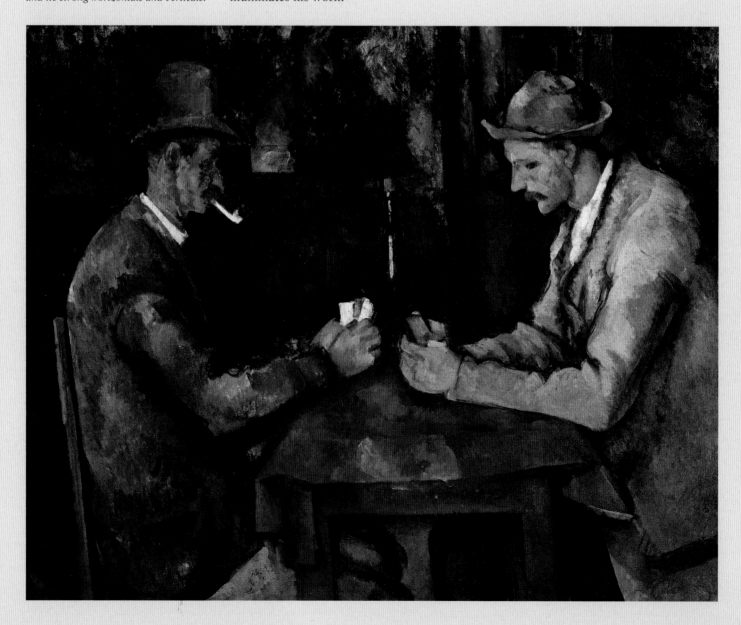

Portrait sittings for Cézanne were extremely taxing for his models, requiring extraordinary feats of patience. He demanded uncomfortable poses that had to be held for hours at a stretch. Sitters were generally not allowed to talk or change their pose, and when Marie Gasquet, the daughter of an old friend, dozed off during her sitting, he abandoned her portrait in a rage. As an adult, Cézanne's son, Paul, recalled the agony of posing while his father worked in total silence.

Cézanne needed a week of daily sessions simply to sketch the contours of the model, showing a few shadows and indications of colour, and this was just a start. It was not unusual for him to demand a hundred sittings for one portrait and even then he sometimes destroyed the final result. Even if a portrait survived, he was often dissatisfied with it, feeling that most of his efforts were incomplete. Occasionally he conceded that he had made 'some progress'. After multiple sittings for his portrait of Vollard, he admitted to being 'not unhappy with the front of the shirt'.

Cézanne's most enduring model was himself. His series of self-portraits, begun in his twenties and painted throughout his life, reveal a determined, obstinate character, gazing out of the painting with an uncompromising stare. The portraits chart the progress of the artist and the man. In the early portraits, he presents himself as a rebel, with untamed hair and a bushy beard. In those from his middle years, he is more smartly dressed and his beard is neatly trimmed. In his final self-portrait, completed in 1900, he appears small and shrunken, but with an expression of stoic resignation.

As well as single portraits, Cézanne produced some paintings with two or more figures. Between 1890 and 1892, he painted five pictures of card players, using day-labourers at the Jas de Bouffan as his models. Some show a group of players, while others feature just two men, playing face-to-face across a table. The two figures achieve a pleasing balance, both lost in contemplation of their own cards. In the view of the British artist and critic Roger Fry, the pair possess 'the dignity and solemnity of an ancient monument'.

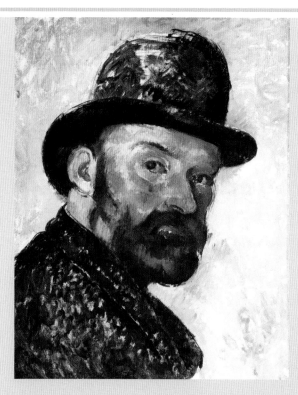

Self-Portrait in a Bowler Hat, 1885–6. *This self-portrait, painted when Cézanne was in his forties, presents a well-dressed figure with an evident air of self-confidence. The painting displays a technique perfected in Cézanne's portraits of using ordered, parallel brushstrokes to create a sense of volume.*

Young Italian Woman at a Table, 1895–1900. *Leaning on a table and resting her head in her hand, this young woman conveys a timeless sense of thoughtful melancholy. The plainness of her clothing contrasts with the subtle patterns of the fabric on the table, and while she seems solid and immoveable, the spaces behind and around her can appear contradictory and even confusing, giving tension and movement to the composition.*

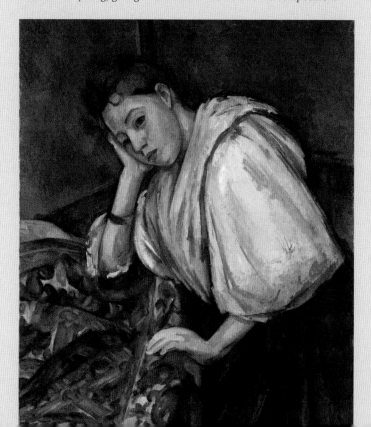

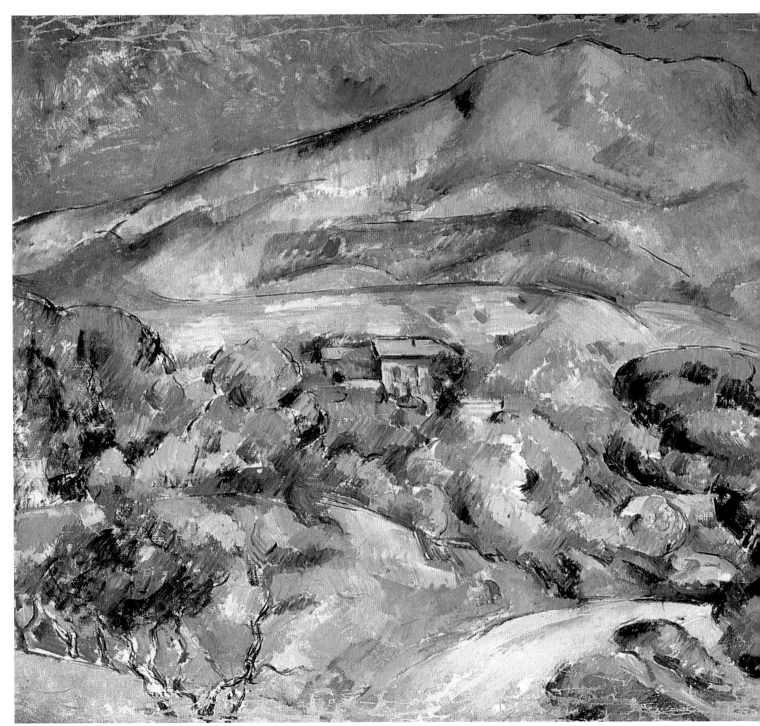

CHAPTER 5
The Final Years

After the bruising experience of the Third Impressionist Exhibition in 1877, Cézanne refused to exhibit his work, acquiring an almost mythical status as a reclusive and secretive artist. One Paris critic wrote, 'Cézanne seems to be a fantastic figure. Although still living, he is spoken of as if he were dead,' while the critic Gustave Geffroy described him as 'a person at once unknown and famous, having only rare contact with the public and yet considered influential by the restless seekers in the field; known only by a few, living in savage isolation'.

For those 'restless seekers' who longed to see Cézanne's work, it was possible to track down some examples. A few paintings were owned by friends and collectors, such as Émile Zola, Paul Alexis, Victor Choquet, Dr Gachet, and the artists Camille Pissarro and Gustave Caillebotte. There were also some works for sale in the dark and poky shop of the eccentric art dealer Julien Tanguy.

For many years, Tanguy's shop was the only place in Paris where people could buy Cézanne's work. Tanguy guarded the paintings like precious treasures, displaying them one at a time and pointing out their virtues with shining eyes. One American customer described Tanguy's habit of 'first looking down at [a Cézanne] painting with all the fond love of a mother, and then looking up at you over his glasses, as if begging you to admire his beloved children'. Visitors who came to see the Cézannes included Vincent van Gogh, Maurice Denis, Paul Signac, Georges

Mont Sainte-Victoire above the Tholonet Road, 1896–8. Cézanne painted Mont Sainte-Victoire more than 80 times, gradually distilling its outline into flattened geometric shapes. In all of his paintings, he remained determined to interpret precisely what he saw, once telling his young friend Joaquin Gasquet, 'I would rather smash my canvas than invent or imagine a detail.'

Apples and Oranges, c.1899.
*This ground-breaking still life
with its bold experiments in
shifting viewpoints has inspired
lasting admiration. As the artist
and critic Roger Fry wrote
of Cézanne's later still lifes,
'Though it would be absurd
to speak of the drama of his
fruit dishes, his baskets of
vegetables, his apples spilt on
the kitchen table, none the less
these scenes in his hands leave
upon us the impression
of grave events.'*

Seurat, Émile Bernard and Paul Gauguin – artists who would form the core of the Post-Impressionist movement. All of them were influenced by the art of Cézanne, and Signac and Denis were especially devoted followers.

GAINING FAME

In the late 1880s, the general public finally began to be able to see the art of Cézanne once more. Cézanne's painting *The House of the Hanged Man* (see page 44) appeared in the Paris World Fair of 1889 at the insistence of Victor Choquet, who refused to lend other items from his collection unless a work by Cézanne was displayed. In the same year, Cézanne was invited to show his work in Brussels with the young Belgian group known as 'Les Vingt' (The Twenty). At first he refused, but he changed his mind when he heard that van Gogh and Sisley had been included in the exhibition, informing the

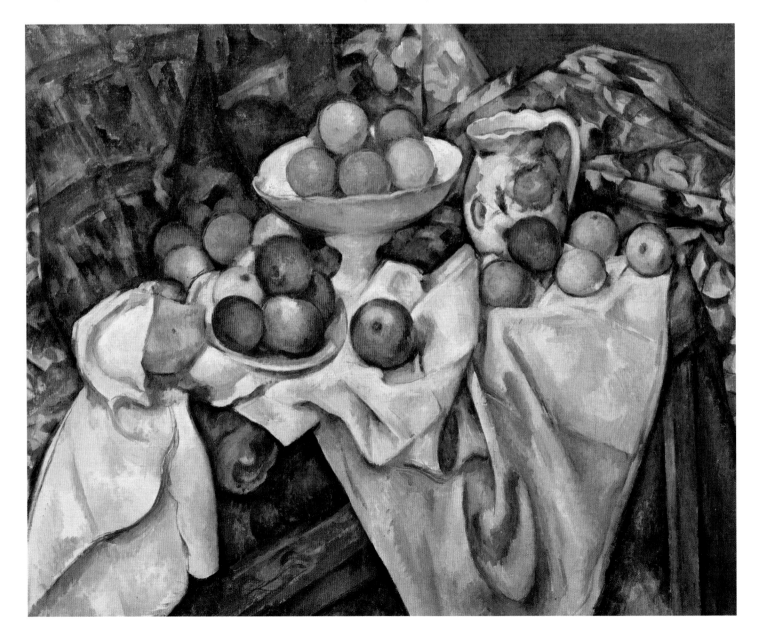

Homage to Cézanne, *1900*, *Maurice Denis. Denis shows a group of artists gathered around a Cézanne still life, displayed in the premises of the art dealer Ambroise Vollard. Odilon Redon stands on the far left listening to Paul Sérusier and the group also includes Edouard Vuillard, Maurice Denis, Paul Ranson, Ker-Xavier Roussel, Pierre Bonnard (smoking a pipe) and Marthe Denis, the painter's young wife.*

organizer that, 'In view of the pleasure of finding myself in such good company, I do not hesitate to modify my resolve.'

The next move towards wider exposure came in 1893 when the artist Gustave Caillebotte died, leaving his magnificent collection of contemporary paintings to the Luxembourg Museum. The bequest provoked outrage among members of the art establishment, who feared that introducing such impure art into the museum could distract young men from the study of 'serious art'. Only a small proportion of the bequest was displayed, but this included two works by Cézanne. This move was followed by some major sales of Cézanne's work, including an auction of Tanguy's stock after his death. Gustave Geffroy published an article to mark the sale, praising Cézanne's contribution to the Impressionist movement.

A ONE-MAN EXHIBITION

As public interest in Cézanne grew, the time seemed ripe for a major retrospective of his work. In 1895 the young art dealer Ambroise Vollard decided to organize a show, with the encouragement of Pissarro, Monet and Renoir. After numerous difficulties, Cézanne agreed to send 150 canvases from Aix, representing his work between 1868 and 1894.

The exhibition took place in Vollard's small shop – a space too small to show all the works at once – and attracted much attention. As usual, there were some detractors who spoke of the 'nightmarish sight of these atrocities in oil', but many others were enthralled. Pissarro wrote to his son Lucien, describing his delight at Cézanne's show 'in which there are exquisite things, still lifes of irreproachable perfection…landscapes, nudes, and heads that are unfinished but yet grandiose'. Renoir, Monet and Degas were all astonished by the quality of the paintings and drawings. Degas and Monet both bought paintings and Renoir and Degas were so enthusiastic about a drawing of fruit that they drew lots for it.

Following the success of the one-man exhibition, Vollard became Cézanne's new dealer. An astute businessman, he would even accept canvases that were unfinished or torn, although Cézanne sometimes suspected he didn't pay very well. Vollard generally dealt with Cézanne's son, Paul, who acted as his agent, taking 10 per cent of his father's profits – an arrangement that pleased Cézanne, who freely admitted that in practical matters his son was very much smarter than he was. Paul took the role of agent seriously, even trying to influence his father's choice of subjects and urging him to

paint women instead of men, as such works would be much more sellable. However, this was a step too far for Cézanne, whose fear of women increased with age, leading him to refuse to work with young female models.

As the nineteenth century drew to a close, Cézanne's work began to be seen in the grand exhibition halls. In 1899, he agreed to send three paintings to the Salon des Indépendants, and the following year his work was included in a big centennial exhibition in Paris. In 1901, he again exhibited in the Salon des Indépendants, an exhibition which included a large canvas by Maurice Denis entitled *Homage to Cézanne* (see page 77). The painting showed a group of young artist friends, all gathered around a still life by the master. Denis could not portray Cézanne himself because at that time he had not yet met him, but the painting was a public declaration of the debt that the younger generation of artists owed to Cézanne.

In the early years of the twentieth century, Cézanne's fame grew steadily as his work appeared in Paris, Vienna, Brussels and Berlin. Meanwhile, back in his home town of Aix, a group called the Society of the Friends of Art invited him to show his work. Cézanne exhibited paintings in 1902 and 1906, listing himself in the catalogue as a 'pupil of Pissarro' in a modest and generous tribute to the artist who had made a profound impact on his work.

LEAVING THE JAS DE BOUFFAN

Cézanne's mother, Elisabeth, spent her final years at the Jas de Bouffan, where she was cared for tenderly by her son. As her health declined, Cézanne organized outings by horse-drawn carriage, carrying her from the house to the carriage and back, and keeping her amused with his stories. When Elisabeth died in 1897 at the age of 82, Cézanne was distraught. Soon, his misery was compounded as his sister Marie took over the running of the house and the family descended into bitter quarrels about the division of the estate. Eventually Maxime Conil, husband of Cézanne's sister Rose, came to the decision that the Jas de Bouffan would have to be sold in order to settle some outstanding debts, leaving Cézanne without a permanent home.

Cézanne was heartbroken to leave the beautiful house and gardens that had provided him with refuge and inspiration for 40 years, and he turned for comfort to a younger friend, Joachim Gasquet, who was living nearby. Gasquet later described Cézanne's 'uncertainty, his struggles and his despair' at the time of the sale. 'Above all I remember his pitiful arrival, one evening, his mute expression, the sobs that prevented him speaking, and the sudden tears that brought relief.' The incident that had caused Cézanne such distress was the discovery that his sisters, without consulting him, had set about burning all the family furniture in a large bonfire in the grounds of the house.

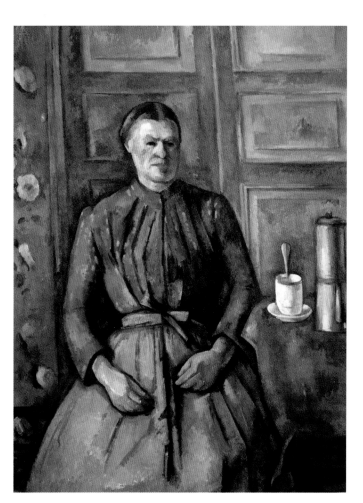

Woman with a Coffee Pot, c.1895. *This painting shows a countrywoman who was probably one of the domestic staff at the Jas de Bouffan. Cézanne has rendered her rough working hands and plain but dignified face in a sympathetic manner, but the portrait is also an exploration of form. As the critic Lionello Venturi wrote, the woman 'gives the impression of an imposing natural force. She is planted there like a strong tower.' This tower shape is balanced by the many horizontals in the painting and echoed in the coffee pot and the cup and spoon.*

PLACES TO PAINT

Displaced from his beloved family home, Cézanne found an apartment in the centre of Aix, on the upper floors of the building that had once been his father's bank. He had an attic studio built into the roof, and spent much of his time painting there, cared for by a housekeeper, Madame Brémond. Meanwhile, Hortense and Paul were mainly based in Paris.

While Cézanne had his base in town, there were other places he could go to paint. Sometimes he headed for the Bibémus Quarries or for the countryside around the Château Noir. The château was a recently constructed neo-Gothic castle designed to mimic antique ruins, and its romantic position on the slope of a hill with a distant view of Mont Sainte-Victoire appealed very strongly to his imagination.

Cézanne arranged to rent a room in the château where he could store his canvases and painting equipment, and also paid for another room in a farmer's cottage further down the hillside. There he sometimes lodged with the farmer, Eugène Couton, rather than making the journey back to town at the end of a long working day.

Meanwhile, Cézanne was looking round for a larger property in the countryside where he could establish a large-scale studio, and in 1901 he found the ideal place, not very far from the Château Noir.

Château Noir, c.1900–4. The dramatic setting of the Château Noir captivated Cézanne, and he repeatedly painted it both from close up and from a distance. In this picture, his technique of using small parallel brushstrokes to apply his paint can be clearly seen.

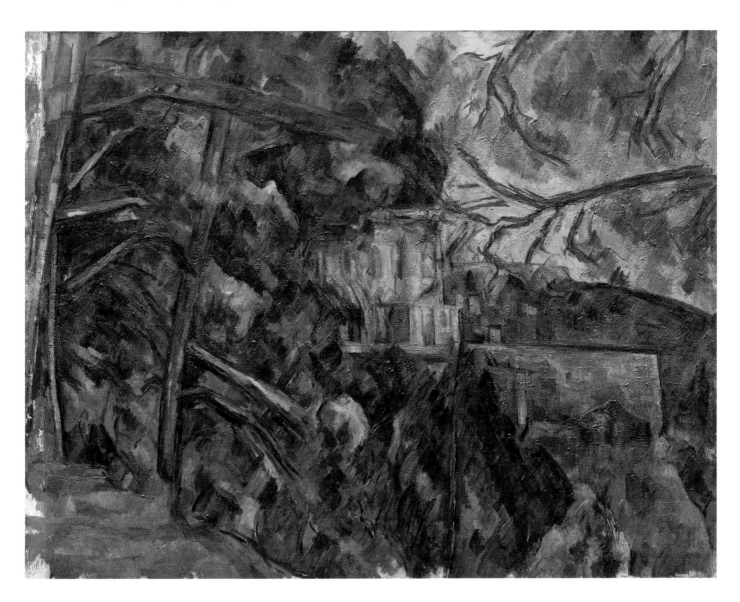

Cézanne's studio has been preserved as a museum, with his paints, equipment and clothes left just as they were in his time, along with some of the objects that he used for his still life compositions.

CÉZANNE'S TREE

On his first visit to Les Lauves, Cézanne spotted an ancient olive tree, and during construction work he had a small wall built around it to protect it from damage. Later, when he had settled in, he would visit the tree at the end of the day, to talk to it, touch it and even embrace it. Once, he told Joachim Gasquet, 'It's a living being. I love it like an old friend. It knows everything about my life and gives me excellent advice. I would like to be buried at its feet.'

THE ATELIER DES LAUVES

In 1901, at the age of 62, Cézanne purchased a small plot of land in a hilly area to the north of Aix, known as Les Lauves. The land was in a sheltered, south-facing spot and had been laid out in olive groves and orchards for fruit trees. From the small estate, there was a spectacular view of the town, dominated by the Cathedral of Saint-Saveur. It was the perfect place for a studio, and Cézanne worked with an architect and a master mason to design the Atelier des Lauves, a simple building constructed from local stone with Provençal roof tiles.

The Atelier des Lauves was perfectly suited to a man who devoted his life to his art. Its downstairs rooms provided basic accommodation – a living room and a bedroom, a toilet, a kitchen and a small pantry – while most of the upper floor was taken up by a studio. This was a large, airy room with pale grey walls and a plain pine floor, a huge north-facing window and two smaller windows facing south. The studio also had a very unusual feature: a narrow slot in the

wall, with a metal shutter, rather like a giant letter box extending down to the ground floor, that allowed outsized canvases to be delivered up to the studio and later posted out to the world. In this ideal space, Cézanne felt at last that he was ready to realize his dream of painting canvases on a grand scale.

QUARRELS AND COMPANIONSHIP

By the time Cézanne reached his sixties, he had become estranged from nearly all the artists he had met in Paris. Most of them stayed away, and those who visited him had to put up with his sudden outbursts of temper. In 1896, Francisco Oller, a friend from his days at the Académie Suisse, travelled to Aix to paint with Cézanne but after he dared to offer some painting advice, Cézanne wrote him an angry letter banning him from his house. Oller reported that Cézanne sometimes made disparaging comments about his artist friends, including Pissarro and Monet. Pissarro was so saddened at these reports that he sought the advice of a doctor friend who assured him that Cézanne was sick and could not be held responsible for his fits of rage. Pissarro reacted sadly to this judgment, writing to his son Lucien, 'Is it not sad and a pity that a man endowed with such a beautiful temperament should have so little balance?'

But while Cézanne turned away from his old friends, he could be remarkably open to younger companions. He took long walks with Joachim Gasquet, the son of a boyhood friend, during which he expounded his theories of art, and Gasquet introduced him to a circle of friends who gathered in cafés in Aix to learn from the master. In the company of these youthful admirers, Cézanne relaxed and enjoyed himself, although he was still prey to unpredictable outbursts, taking sudden offence at a careless phrase or comment or flying into a rage if anyone should accidentally touch his arm. Many of Cézanne's young friends were writers and poets, but he also encouraged some aspiring artists: Charles Camoin, Joseph Ravaisou and Louis Le Bail were all given advice and they sometimes accompanied him on painting expeditions.

As well as his young admirers, Cézanne had some old friends in Aix. Numa Coste, Paul Alexis and Philippe Solari had all known Cézanne since boyhood and enjoyed

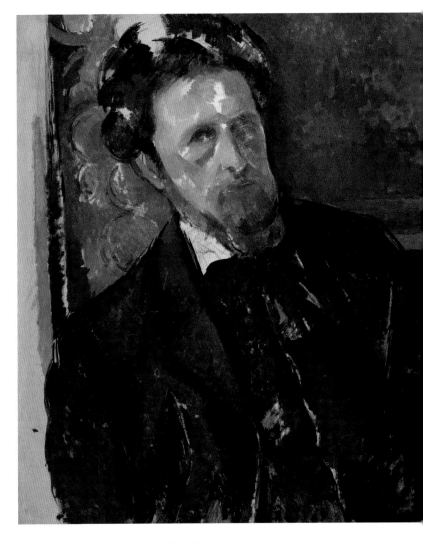

Portrait of Joachim Gasquet, c.1896. *This intriguing portrait with its striking diagonal axis presents a thoughtful young man, whose penetrating gaze is made especially disturbing by the partial obscuring of one of his eyes. The semi-abstract circles in the fabric at the top corner echo the blues and golds elsewhere in the painting and the deliberate white patches add a sense of lightness to the composition.*

his company. In 1891, Paul Alexis reported that he was one of the very few lively spirits in town. 'Fortunately Cézanne puts some spirit and life into my daily round. He at least is vibrant, expansive and alive.' However, his friends also recorded his moods of depression and doubt.

Perhaps most of all, Cézanne appreciated the undemanding company of country folk. On his carriage rides to painting spots, he would talk to the driver, confiding, 'The world does not understand me and I do not understand the world...that is why I have withdrawn from it.'

THE BATHERS

In his final years, Cézanne worked on three giant canvases of bathers. (One of them is now displayed in London at the National Gallery, one is in the Philadelphia Museum of Art and the third is part of the private Barnes Collection.) These imposing works had each been in progress for many years and mark the culmination of a series of at least 80 versions of the same subject. In his earlier paintings, the bathers are generally male and are often shown swimming in a river, a scene that must have been inspired by Cézanne's boyhood adventures. In his three large-scale paintings, however, the figures have become more static and monumental, resembling a group of ancient statues. All the figures are naked and all appear to be female, although some seem strangely androgynous. These intriguing paintings have been interpreted as Cézanne's vision of a golden age in which human beings were able to live in harmony with nature. They can be seen as part of a long artistic tradition of depicting idealized figures in a landscape; in particular, they owe a debt to the Renaissance artist Nicholas Poussin. Cézanne once wrote that he wanted to 'redo Poussin after nature'.

The artist Émile Bernard witnessed the creation of *The Large Bathers* and dared to voice a critical response. He considered the drawing of the figures 'rather deformed' and asked Cézanne why he did not use models for his nudes. In reply, the master asserted that at his age 'one should refrain from stripping women in order to paint them' and explained to Bernard that he relied on the drawings of female models that he had made in his twenties at the Académie Suisse.

Bernard was not alone in his criticism of Cézanne's figures, with one art critic in 1907 describing them as 'carcasses'. But for many others, Cézanne's bathers are figures of great power. The sculptor Henry Moore described his first sight of *The Large Bathers* canvas in Philadelphia as one of the most intense experiences of his life: 'What had a tremendous impact on me was the big Cézanne, the triangular bathing composition with the nudes in perspective, lying on the ground as if they'd been sliced out of mountain rock. For me this was like seeing Chartres Cathedral.'

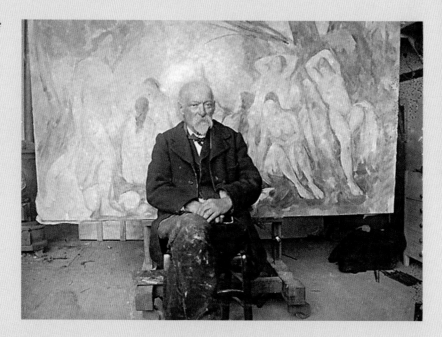

While he was visiting Cézanne at the Atelier des Lauves, Émile Bernard persuaded Cézanne to sit for a photograph in his studio. His photo shows Cézanne in paint-spattered clothes, sitting in front of a large canvas of The Bathers, *looking composed but watchful.*

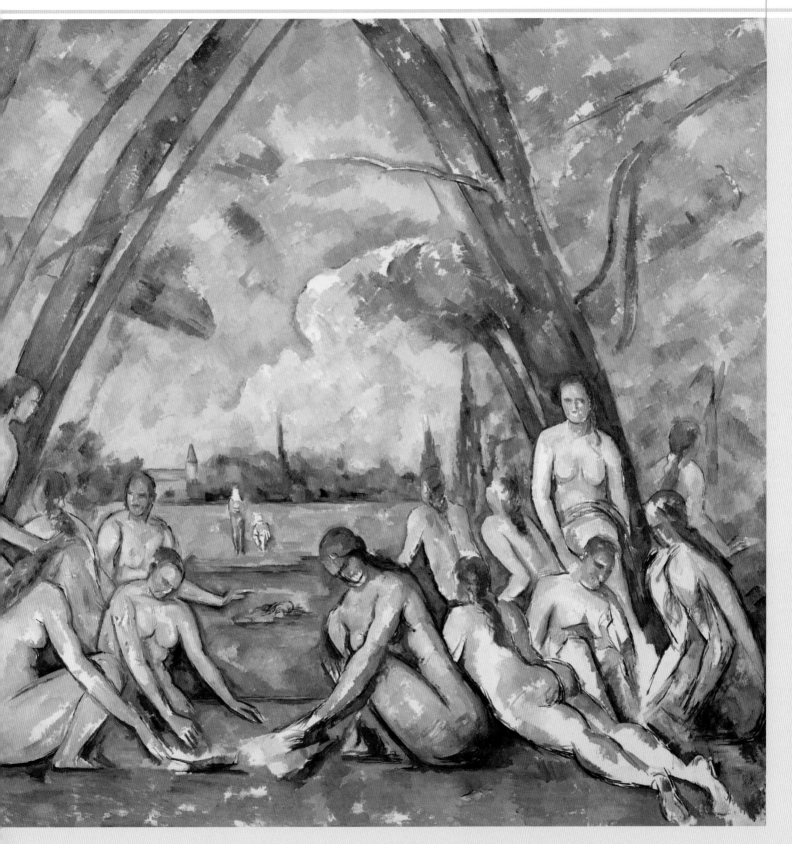

The Large Bathers, 1900–6. *The version held in the Philadelphia Museum is the largest of Cézanne's studies of bathers, and some critics consider it to be his masterpiece. In this ambitious painting, he contains his human forms in a triangular structure that is often found in classical paintings. The painting may perhaps be interpreted as the achievement of harmony between humanity and nature, and between 'modern' and classical art.*

LAST LANDSCAPES

In his work as a landscape painter, Cézanne liked to return to a place repeatedly, painting the same view from different angles and in different light. Some of his favourite painting spots around Aix-en-Provence included the Bibémus Quarries and the Château Noir, but the view that most obsessed him in his final years was the limestone crag of Mont Sainte-Victoire. This magnificent landmark could be viewed from the hillside close to the Atelier des Lauves and between the years 1901 and 1906, he painted the mountain repeatedly, completing at least 11 oils and 19 watercolours.

The view of Mont Saint-Victoire, sometimes framed by trees and sometimes viewed over a flat, rocky landscape, became the focus for Cézanne's experiments in representing nature. In these painstaking studies, he worked to find the structure unifying the scene, simplifying it to its basic elements – verticals, horizontals and diagonals – and building up his colours and forms within this framework. He employed his 'constructive strokes' (regular patterns of parallel diagonal and vertical brushstrokes) to convey a sense of depth and structure, and these parallel brushstrokes also suggest the effect of shimmering sunlight on rocks and trees.

Cézanne's method of painting involved building up a total scene by adding patches of colour across the canvas until he had created a balanced whole. This slow and patient approach was described by the author and art critic Joachim Gasquet, who accompanied the master on some of his painting expeditions. Gasquet described watching a canvas become 'slowly saturated' as the image which Cézanne had first sketched out with rapid charcoal strokes began to 'emerge in coloured patches that framed it from all sides'. He explained how Cézanne carefully created the form of each object, testing out each shade, until the landscape 'appeared to vibrate' and described how 'every day, he imperceptibly balanced out all these values in confident harmony, linking them with each other in a muted brightness'.

Cézanne's progress in front of the landscape was agonizingly slow. As he explained to Émile Bernard, 'I work very slowly because nature presents itself to me in great variety and it is my unremitting aim to make progress.' Often, he despaired of his efforts, suddenly abandoning a painting. Nevertheless, he believed that something worthwhile could be achieved, confiding to

Pine Trees and Rocks above the Château Noir, c.1900. In this watercolour study, Cézanne has narrowed the focus of his gaze to concentrate on the basic elements of rocks, trees and sky.

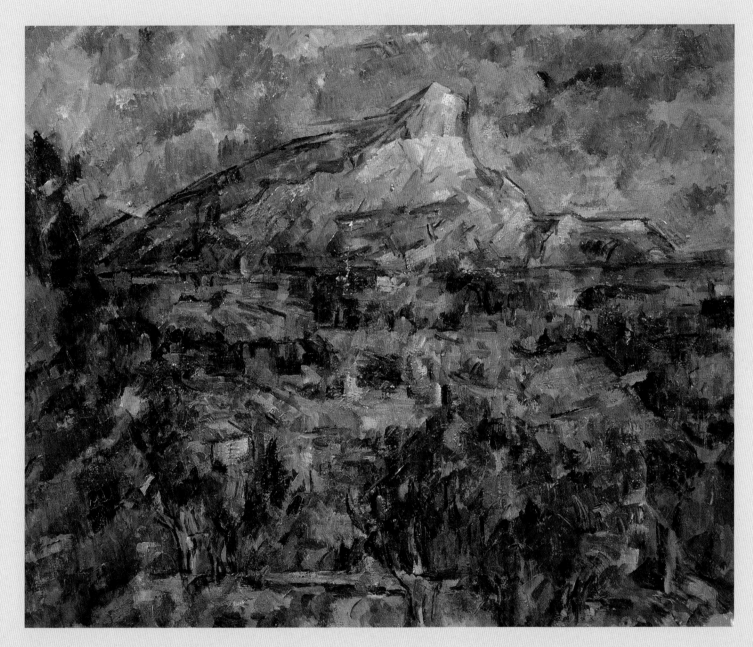

his friend and patron Victor Choquet: 'There will be treasures to carry away from this region.'

In 1904, Cézanne wrote to Émile Bernard, giving his advice on painting from nature. His words have been followed by artists ever since: 'May I repeat what I told you here: treat nature by means of the cylinder, the sphere, the cone, everything brought into proper perspective so that each side of an object or a plane is directed towards a central point. Lines parallel to the horizon give breadth...lines perpendicular to this horizon give depth. But nature for us men is more depth than

Mont Sainte-Victoire, c.1904–6. Cézanne's late studies of Mont Sainte-Victoire are filled with energy as the different elements of the picture react together. In this oil painting, he gives the mountain flank a double outline, making it appear to shimmer with life.

surface, whence the need to introduce into our light vibrations, represented by the reds and yellows, a sufficient amount of blueness to give the feel of air.'

Cézanne explained his painting method as a response to the physical sensations he experienced when looking at a landscape: 'Painting from nature is not copying the object, it is realizing one's sensations.'

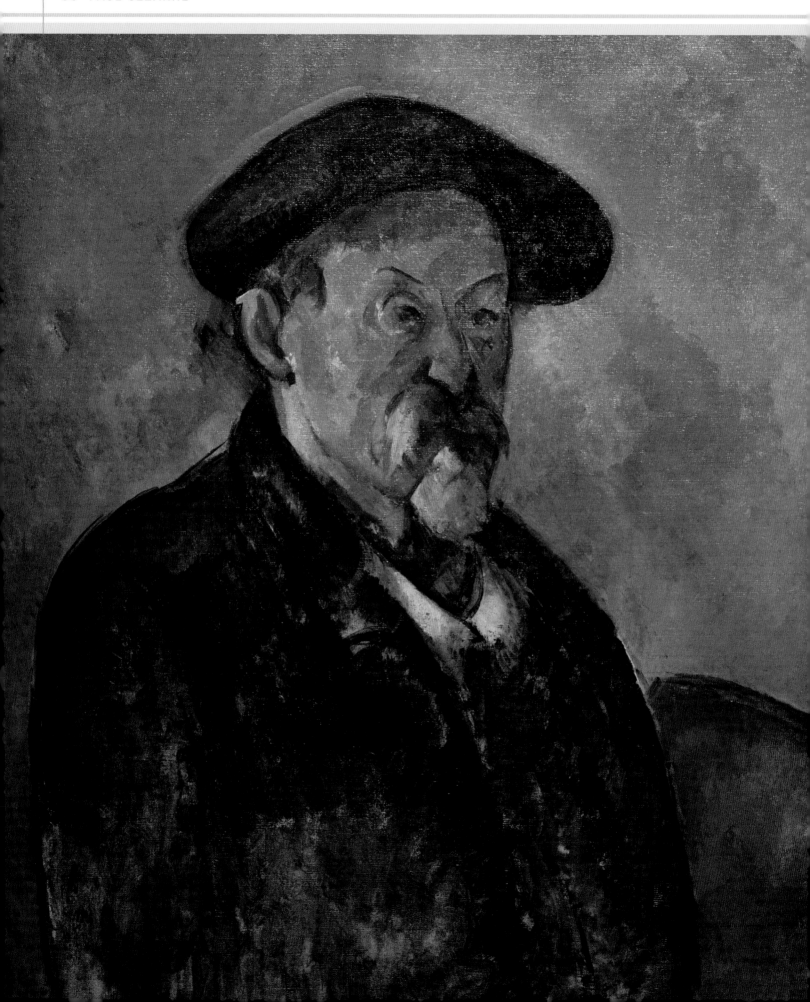

The farmer at the Château Noir, in whose house
Cézanne sometimes stayed, remembered his lodger as
fiercely unapproachable while working but friendly and
talkative at the end of the day, and in Cézanne's last
years he gained great comfort from the companionship
of Vallier, the old gardener who worked on his estate
at the Atelier des Lauves. Indeed, Cézanne became so
close to Vallier that he even allowed him to massage his
aching legs, despite a lifelong hatred of being touched.

FAILING HEALTH

By the 1900s, Cézanne's health was failing. The diabetes
he had developed a decade earlier had been growing
steadily more severe. He suffered from aching legs,
kidney trouble, and a painful swollen foot. He had
frequent coughing fits and was sometimes laid low by
bronchitis. He also complained about distorted sight
and 'brain trouble' – periods when he felt unable to
think clearly. And yet, despite these problems, he was
determined to press on. He told one of his new young
friends, 'You are young, you have vitality…As for me,
I'm getting old. I won't have time to express myself…
Let's get to work.'

Cézanne drove himself harder than ever in the last
years of his life, both in his studio and in the countryside,
often rising before dawn so he could paint outside before
the heat became too intense. He was painfully aware
that he was getting closer to his artistic goals just as time
seemed to be running out. In a letter to Émile Bernard
he confided, 'Now it seems to me that I'm seeing better
and thinking more clearly about the direction of my
studies. Will I reach the goal which I've sought so hard
and pursued for so long? I hope so.' And to Ambroise
Vollard he wrote, 'I work tenaciously…I glimpse the
promised land…will I be able to enter?…I've made some
progress. Why so late and so laboriously?'

*The Gardener Vallier, 1906. In his final years, Cézanne
painted a series of portraits of Vallier, capturing the
old man's calm air of self-possession. The inky black of
Vallier's clothes is enlivened by many touches of colour,
while the simplified background of greens and browns
evokes the tranquillity of the natural world.*

*Self-Portrait with Beret, 1898–1900. Cézanne began
a campaign of self-portraiture in the 1870s and
continued it through the next 30 years. This is his last
known self-portrait, painted with a deliberate sense of
detachment as he looks away from the viewer. It shows
an isolated, shrunken-looking old man, but one who
still possesses a determined spirit.*

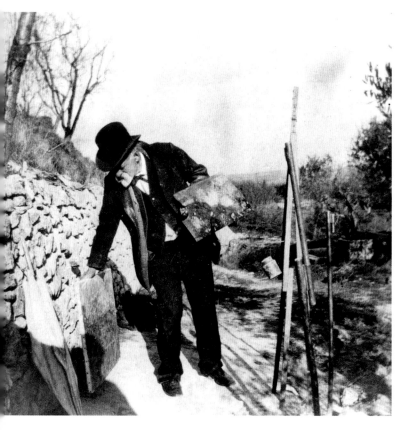

Photograph by Ker-Xavier Roussel, 1906. Roussel's photographs show Cézanne preparing his materials, looking intently at the view, then leaning towards his canvas, preparing to paint. As the critic Gustave Geffroy later wrote, Cézanne is shown at his easel 'truly alone in the world, ardent, focused, alert, respectful'.

YOUNG VISITORS

Fortunately, some records survive for the final years of Cézanne's life. In 1904, the artist Émile Bernard stayed for a month in Aix, sometimes accompanying Cézanne on his painting expeditions and sometimes working on his own paintings in a downstairs room of the studio at Les Lauves. Working at such close quarters, Bernard had a unique insight into the remarkably slow pace of Cézanne's painting, with long pauses for thought between each move. He described the experience of hearing Cézanne at work in his studio, pacing slowly back and forth in 'a meditative walk' and remembered how 'he would frequently come downstairs, go into the garden to sit down, and rush back upstairs'. This impression of thoughtful deliberation is confirmed by Joachim Gasquet's recollection that Cézanne sometimes let 20 minutes go by between each stroke of paint.

In January 1906 two young artists, Maurice Denis and Ker-Xavier Roussel, made the pilgrimage to Aix and found Cézanne emerging from Sunday mass at the cathedral. To their great delight, he arranged to meet them after lunch in his favourite painting spot, close to his studio at Les Lauves. While Cézanne painted, the two young men seized the chance to depict the master at work. Denis made sketches that were later turned into a painting, while Roussel took a series of photographs. After his painting session, Cézanne talked cheerfully to his admirers, taking them to his studio and then on to a café, where they drank his health. As a 'thank you' gift, Roussel sent Cézanne a copy of the journal of his artistic hero, Delacroix.

LAST DAYS

After Denis and Roussel's visit in January 1906, Cézanne kept working throughout the rest of the winter and the spring, even though he felt himself weakening. The summer months were especially difficult as he found it impossible to cope with the heat and had to resort to doing most of his painting between the hours of five and eight in the morning. In September, he wrote to his son, Paul, expressing his sadness at the slow pace of his work. In October, he wrote to Paul again, this time with a note of hopefulness, 'I continue to work with difficulty, but in the end there is something. That's the important thing, I think.'

Soon after writing this letter, Cézanne set up his easel in his usual spot on the hillside near the Atelier des Lauves, but was caught in a thunderstorm. As he made his way back down to the road, he collapsed and remained exposed to the rain for several hours before being discovered by a passing laundryman. The man lifted Cézanne on to his cart and took him back to his apartment in town, where he could be cared for by his loyal housekeeper, Madame Brémond.

The following day, Cézanne refused to stay in bed, returning instead to the terrace of the Atelier des Lauves, where he worked on a portrait of the gardener, Vallier. During the day, however, his condition worsened and when he returned to his apartment that night, the doctor was called. The doctor suggested a nurse should attend him but Cézanne refused, and the next day he felt strong enough to send a letter to his paint supplier, reminding him that he needed more paints and stressing the urgency of his order.

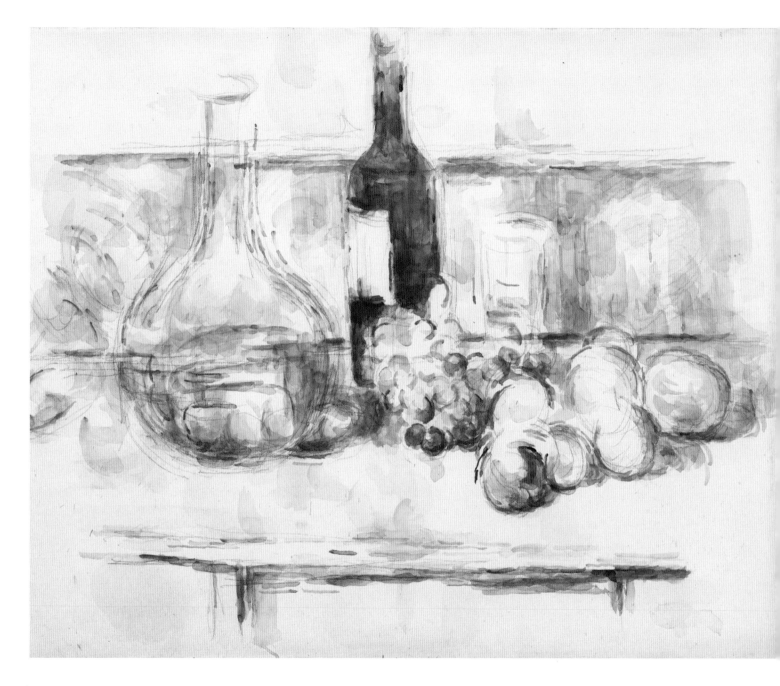

Over the next three days, Cézanne's condition deteriorated once more, prompting his sister Marie to write to Paul asking him to come to Aix, but telling Hortense to put off her visit, as her dressing room had been turned into a studio. It appears that Paul made no move, because two days later Madame Brémond sent a telegram telling Hortense and Paul to come immediately. However, they were too late. Cézanne died from pleurisy on 23 October, with only Madame Brémond by his side.

Still Life with Carafe, Bottle and Fruit, *1906. This delicate still life is believed to be one of Cézanne's final watercolours. He achieved his luminous effect by applying semi-transparent colour washes over pencil outlines.*

During his last days, Cézanne was confined to bed, but an unfinished watercolour was set up within reach, showing a jug, a bottle and some fruit. Whenever he had the strength, he took up a brush and added a few more touches to it. He had always said he wanted to die painting, and he achieved his wish.

EPILOGUE: CÉZANNE'S LEGACY

Many people have claimed that Paul Cézanne was the single most important figure in the development of modern art. Henri Matisse described him as 'a sort of God of painting' and Pablo Picasso called him 'the father of us all'. He is widely admired by artists of all kinds not just for his remarkable talent and innovations but also for his dedication to the task of painting, as he laboured patiently to assemble what he described as a 'harmony parallel to nature'.

Cézanne had an immediate impact on the art of his time. In the late nineteenth century, his work provided a bridge between the relatively short-lived Impressionist movement and the emergence of later styles. While Impressionist painters such as Claude Monet and Auguste Renoir created their effects using light, bright colours and short, dabbing strokes, Cézanne adapted their technique, giving his painting structure as well as surface glitter, lengthening his painting strokes and using colour in bolder, stronger ways. In the words of the art critic John Russell, Impressionism was 'all treble and no bass', and it was Cézanne's great contribution to provide the bass.

Cézanne's art had a powerful influence on a diverse group of younger artists generally known as the Post-Impressionists. Vincent van Gogh, Paul Gauguin, Maurice Denis and Paul Signac were all directly influenced by Cézanne's use of bold blocks of colour. Van Gogh also adopted a method of using long brushstrokes which had similarities with Cézanne's technique.

At the start of the twentieth century, a group known as the Fauvists drew inspiration from Cézanne's rich palette. 'Fauve' means 'wild beast' and the artists gained their name because of their daring use of colour. The group was led by Henri Matisse and André Derain and they were especially motivated by Cézanne's use of vivid colours in his portraits.

Cézanne's vision also lay behind another major movement in twentieth-century art: Pablo Picasso and Georges Braque, joint founders of Cubism, were influenced by both Cézanne's daring experiments with perspective and his passion for the geometric structure of a painting. Cézanne's famous advice to the artist Émile Bernard to 'treat nature by means of the cylinder, the sphere and the cone' can be seen as a clear statement of the principles underlying the Cubist movement.

The impact of Cézanne's art has not diminished with time. The list of those who have acknowledged his influence includes artists as various as Pierre Bonnard, Paul Klee, Robert Motherwell, Jasper Johns, Roy Lichtenstein and Bridget Riley. Writers have also been moved by Cézanne's art and life; Ernest Hemingway, Samuel Beckett and Alan Ginsberg all studied his paintings to help them learn about the art of writing, and Seamus Heaney wrote his poem *An Artist* as a homage to Cézanne. As the artist R.B. Kitaj wrote, 'Cézanne's lessons appear endless to me, encyclopedic like, say, Shakespeare or Beethoven.'

Houses at L'Estaque, 1908, Georges Braque. The experience of seeing Cézanne's work in an exhibition in 1907 impelled Braque to experiment with the style that became known as Cubism. In this painting, he adopts Cézanne's method of reducing buildings to simplified geometric shapes but pushes the process much further. By painting his own version of one of Cézanne's favourite landscapes, Braque is paying a deliberate homage to his predecessor.

TIMELINE

1830s

'39 Paul Cézanne is born on 19 January in Aix-en-Provence, France, to Louis-Auguste Cézanne and Elisabeth Aubert. Later, two more children are born, his sisters Marie and Rose.

1840s

'44 Cézanne's parents marry, soon after his fifth birthday.

'48 Louis-Auguste opens a bank in Aix. From this time on, the family enjoy a very comfortable lifestyle.

1850s

'52 Cézanne enrols as a pupil at the Collège Bourbon, where he becomes close friends with Émile Zola and Baptistin Baille.

'59 Louis-Auguste buys the Jas de Bouffan, a large country house near Aix. Cézanne begins to study law, but longs to be an artist.

1860s

'61 Cézanne moves to Paris in April to study painting. He paints at the Académie Suisse and meets Camille Pissarro. However, by September he has become demoralized and returns to Aix to start work in his father's bank.

'62 Cézanne moves back to Paris, where he once again studies at the Académie Suisse and copies paintings in the Louvre. For the next six years, he divides his time between Paris and Provence. During this period, he gets to know Claude Monet, Auguste Renoir and Edouard Manet and paints dark, troubled pictures, which he describes as 'ballsy'.

'69 Cézanne meets Marie-Hortense Fiquet, a bookbinder and artists' model. She becomes his mistress and for the next nine years they keep their relationship secret from his father.

1870s

'70 Cézanne and Hortense leave Paris and settle in L'Estaque, near Marseille, to escape the turmoil caused by the Franco-Prussian War. Cézanne becomes fascinated by landscape, and paints his powerful study, *The Railway Cutting*.

'72 Cézanne and Hortense have a son, named Paul. All three move to Pontoise, where Cézanne works with Pissarro, developing a lighter and brighter style, similar to that practised by the Impressionists.

'73 Cézanne, Hortense and little Paul move to Auvers-sur-Oise, close to Pontoise. Cézanne continues to work with Pissarro. He becomes friendly with Dr Gachet and paints *The House of the Hanged Man*.

'74 Cézanne, Hortense and Paul return to L'Estaque. Cézanne exhibits three works in what was later called the First Impressionist Exhibition. His painting *A Modern Olympia* is singled out for special ridicule.

'75 Through Renoir, Cézanne meets the collector Victor Choquet, who becomes a major supporter of his work. He goes on to paint several portraits of Choquet.

'77 Cézanne exhibits 16 works in the Third Impressionist Exhibition, including *The Bathers at Rest*. His work is criticized harshly by some critics but praised by others. Cézanne does not permit his work to appear in a major exhibition again until 1889.

1880s

'81 Cézanne works for a short period in Pontoise with Pissarro and meets Paul Gauguin.

'86 Zola publishes his novel, *L'Œuvre* ('The Masterpiece') basing his character of an unsuccessful artist on Cézanne. This leads to an estrangement between the two friends. Cézanne and Hortense are married and Louis-Auguste dies, leaving his son a substantial inheritance. From this period onwards, Cézanne works mainly at the Jas de Bouffan.

1890s

'90 Cézanne is diagnosed with diabetes. He begins his series of paintings of card players. In the 1890s, he becomes increasingly solitary, rarely leaving Provence. He continues to develop his mature style, with its emphasis on structure, defined by 'constructive strokes'.

1890s continued

'94 Cézanne visits Monet at Giverny, where he meets Auguste Rodin and Gustave Geffroy, an art critic and admirer of his work.

'95 Ambroise Vollard stages an exhibition of Cézanne's work. It is a commercial success and his reputation starts to grow.

'99 The Jas de Bouffan is sold, following the death of Cézanne's mother two years earlier. He takes an apartment in the centre of Aix, but sometimes stays with a farmer near the Château Noir. His ground-breaking still-life study, *Apples and Oranges*, dates from around this time.

1900s

'02 Cézanne has a studio built at Les Lauves. Over the next six years, until his death, he works ceaselessly on his technique, painting landscapes, portraits, still lifes, and his series of large-scale paintings of bathers. Many of his landscape paintings from this period feature the peak of Mont Sainte-Victoire.

'04 Émile Bernard stays with Cézanne, observes him at work and photographs him in his studio.

'06 Cézanne is greatly weakened. In October, he is caught in a storm while painting and dies a week later, aged 67.

FURTHER INFORMATION

Cézanne, Ulrike Becks-Malorny, Taschen, 2016
Cézanne: A Life, Alex Danchev, Profile Books, 2012
Cézanne Portraits, John Elderfield, National Portrait Gallery, London, 2017
Interpreting Cézanne, Paul Smith, Tate Publishing, 1996
Paul Cézanne: A Biography, John Rewald, Henry N. Abrams, Inc., 1986
Paul Cézanne: Drawings and Watercolours, Christopher Lloyd, Thames and Hudson, 2015.

I am indebted to Alex Danchev and John Rewald for their lively accounts of Cézanne's life and their extensive quotation from private correspondence.

Galleries and museums that hold major collections of Cézanne's work:
Musée d'Orsay, Paris, France
The Courtauld Gallery, London, UK
Philadelphia Museum of Art, USA
State Hermitage Museum, St Petersburg, Russia.

Cézanne's studio: Les Lauves, Aix-en-Provence, France.

LIST OF ILLUSTRATIONS

Page 2
Man Smoking a Pipe, c.1891, oil on canvas, 92.5 × 73.5 cm (36½ × 29 in), State Hermitage Museum, St Petersburg, Russia. Bridgeman Images.

Page 7
Still Life with Plaster Cupid, c.1894, oil on paper, 70.6 × 57.3 cm (27¾ × 22½ in), The Courtauld Gallery, London, UK. Bridgeman Images.

Pages 8–9
Mont Sainte-Victoire, c.1902–6, oil on canvas, 57.2 × 97.2 cm (22½ × 38¼ in), Metropolitan Museum of Art, New York, USA. Gift of Walter H. and Leonore Annenberg, 1994, bequest of Walter H. Annenberg, 2002.

Page 10
The Painter's Father, Louis-Auguste Cézanne, c.1865, mural transferred to canvas, 167.6 × 114.3 cm (66 × 45 in). National Gallery, London, UK. Fine Art Images/Diomedia.

Page 11
Girl at the Piano – Overture to Tannhauser, c.1868, oil on canvas, 57.8 × 92.5 cm (22¾ × 36½ in). State Hermitage Museum, St Petersburg, Russia. Classicpaintings/Alamy Stock Photo.

Page 12
Paul Alexis Reading to Émile Zola, 1869–70, oil on canvas, 133.5 × 163 cm (52½ × 64⅛ in). Museu de Arte de São Paulo, Brazil. Heritage Images/Diomedia.

Page 13
Large Pine and Red Earth, 1895–7, oil on canvas, 72 × 91 cm (28⅓× 35¾ in), State Hermitage Museum, St Petersburg, Russia. Photo by DeAgostini/Getty Images.

Page 14
Study of Bathers, 1892–4, oil on canvas, 26 × 40 cm (10¼ × 15¾ in), Pushkin Museum, Moscow, Russia. Universal Images Group/Universal History Archive/Diomedia.

Page 15
The Artist's Mother, 1866–7, oil on canvas (verso), 55.9 × 35.4 cm (22 × 14 in), Saint Louis Art Museum, Missouri, USA. Bridgeman Images.

The Artist's Sister, 1866–7, oil on canvas (recto), 55.9 × 35.4 cm (22 × 14 in), Saint Louis Art Museum, Missouri, USA.

Page 16
Portrait of the Painter Achille Empéraire, 1867–8, oil on canvas, 200 × 120 cm (78¾ × 47¼ in), Musée d'Orsay, Paris, France. Bridgeman Images.

Page 17
Louis-Auguste Cézanne, the Artist's Father, Reading 'L'Événement', 1866, oil on canvas, 198.5 × 119.3 cm (78⅛ × 47 in), National Gallery of Art, Washington DC, USA, Collection of Mr and Mrs Paul Mellon.

Page 18
Photograph of the beach at Tregastel, 1890–1900. Private Collection/Bridgeman Images.

Page 19
The Kinuta Jewel River in Settsu Province, Utagawa Hiroshige, 1857, woodblock print (ink and colour on paper), 36.2 × 24.4 cm (14¼ × 9⅝ in), Metropolitan Museum of Art, New York, USA. Mary Griggs Burke Collection, Gift of the Mary and Jackson Burke Foundation, 2015.

Pages 20–1
The Abduction, 1867, oil on canvas, 88 × 170 cm (34⅔ × 67 in), The Fitzwilliam Museum, Cambridge, UK. Artpics/Alamy Stock Photo.

Page 22
Portrait of the Artist, c.1862–4, oil on canvas, 44 × 32 cm (17⅓ × 12½ in), Private Collection/Bridgeman Images.

Photograph of the young Cézanne, c.1860. Design pics Historical/Ken Welsh/Diomedia.

Page 23
Photograph of the Avenue de l'Opéra, Paris, 1860, historic copper-plate etching. Photo by Bildagentur-online/Getty Images.

Page 24
Boulevard des Capucines, Claude Monet, 1873, oil on canvas, 79.4 × 59 cm (31¼ × 23¼ in). Nelson-Atkins Museum of Art, Kansas City, USA. Bridgeman Images.

Page 25
Jupiter and Thetis, Jean Auguste Dominique Ingres, 1811, oil on canvas, 324 × 260 cm (127½ × 102⅓ in), Granet Museum, Aix-en-Provence, France. Leemage/Corbis via Getty Images.

Page 26
House and Farm at the Jas de Bouffan, 1885–7, oil on canvas, 60.8 × 73.8 cm (24 × 29 in), Narodni Galerie, Prague, Czech Republic. Bridgeman Images.

Page 27
Spring and *Autumn* from the series *The Four Seasons*, 1860–1, mural, detached and mounted on canvas, 314 × 97 cm (123⅝ × 38⅛ in), Petit Palais, Musée des Beaux-Arts de la Ville de Paris, France. Heritage Images/Diomedia.

Page 28
Le Déjeuner sur l'Herbe, Edouard Manet, 1863, oil on canvas, 208 × 264.5 cm (81⅞ × 104⅛ in), Musée d'Orsay, Paris, France. Bridgeman Images.

Page 29
The Murder, 1867–70, oil on canvas, 64 × 81 cm (25⅛ × 31⅞ in), Walker Art Gallery, Liverpool, UK.

Page 30
The Black Marble Clock, c.1870, oil on canvas, 54 × 74 cm (21¼ × 29⅛ in). Stavros S. Niarchos Collection, Paris. Bridgeman Images.

Page 31
Antoine Dominique Sauveur Aubert, the Artist's Uncle, 1866, oil on canvas, 79.7 × 64.1 cm (31⅛ × 25¼ in), Metropolitan Museum of Art, New York, USA. Wolfe Fund, 1951: acquired from The Museum of Modern Art, Lillie P. Bliss Collection.

Page 32
The Barque of Dante, Eugène Delacroix, 1822, oil on canvas, 189 × 241 cm (74⅜ × 94⅞ in), The Louvre, Paris, France.

Page 33
Madame Cézanne Leaning on a Table, 1873–7, oil on canvas, 46 × 38 cm (18⅛ × 15 in), Private Collection. Bridgeman Images.

The Struggle of Love, c.1880, oil on canvas, 38 × 46 cm (15 × 18⅛ in), National Gallery of Art, Washington DC, USA. Gift of the W. Averell Harriman Foundation in memory of Marie N. Harriman.

Page 34
Olympia, Edouard Manet, 1863, oil on canvas, 130 × 190 cm (51⅛ × 74⅞ in), Musée d'Orsay, Paris, France.

Page 35
A Modern Olympia, 1870, oil on canvas, 56 × 55 cm (22 × 21⅝ in), Private Collection. Buvenlarge/Getty Images.

Le Déjeuner sur l'Herbe, c.1870, oil on canvas, 60 × 81 cm (23⅝ × 31⅞ in), Private Collection.

Page 36
Melting Snow at l'Estaque, c.1870, oil on canvas, 73 × 92 cm (28¾ × 36¼ in), Private Collection.

Page 37
The Fishermen's Village at L'Estaque, c.1870, oil on canvas, 42 × 55 cm (16½ × 21⅝ in), Private Collection. Photo © Christie's Images/Bridgeman Images.

Pages 38–9
The Railway Cutting, c.1870, oil on canvas, 80 × 129 cm (31½ × 50¾ in), Neue Pinakothek, Munich, Germany. Bridgeman Images.

Page 40
Portrait of Paul, The Artist's Son, c.1875, oil on canvas, 17.1 × 15.2 cm (6¾ × 6 in), The Henry and Rose Pearlman Foundation, Princeton University Art Museum.

Page 41
Portrait of Camille Pissarro, c.1873, pencil on paper, 13.3 × 10.3 cm (5¼ × 4 in), The Louvre, Paris, France. AKG Images.

Page 42
Orchard near d'Osny, Pontoise, Camille Pissarro, 1874, oil on canvas, 54 × 73 cm (21¼ × 28¾ in), Private Collection. Bridgeman Images.

Page 43
Picking Potatoes, Camille Pissarro, 1893, oil on canvas, 46 × 55 cm (18⅛ × 21⅝ in), Private Collection. Photo © Christie's Images/Bridgeman Images.

Page 44
The House of the Hanged Man, c.1873, oil on canvas, 55 × 66 cm (21⅝ × 26 in), Musée d'Orsay, Paris, France. DeAgostini/G. Nimatallah/Diomedia.

Page 45
The House of Père Lacroix, 1873, oil on canvas, 61.3 × 50.6 cm (24⅛ × 20 in), National Gallery of Art, Washington DC, USA. Chester Dale Collection.

Page 46
Man with a Jacket, c.1873, oil on canvas, 32.5 × 25 cm (12¾ × 9⅞ in), The Barnes Foundation, Philadelphia, USA. Bridgeman Images.

Page 47
Flowers in a Small Delft Vase, c.1873, oil on canvas, 41 × 27 cm (16⅛ × 10⅔ in), Musée d'Orsay, Paris, France. Bridgeman Images.

The House of Dr Gachet, 1872–3, oil on canvas, 46 × 38 cm (18⅛ × 15 in), Musée d'Orsay, Paris, France. Bridgeman Images.

Pages 48–9
A Modern Olympia, 1873–4, oil on canvas, 46.2 × 55.5 cm (18⅛ × 21⅞ in), Musée d'Orsay, Paris, France. Photo by DeAgostini/Getty Images.

Page 49
Self-Portrait, c.1873–6, oil on canvas, 65 × 54 cm (25⅝ × 21¼ in), Musée d'Orsay, Paris, France. Bridgeman Images.

Page 50
La Grenouillère, Pierre-Auguste Renoir, 1869, oil on canvas, 66.5 × 81 cm (26⅛ × 31⅞ in), Nationalmuseum, Stockholm, Sweden. Wikimedia Commons: Gift 1924 by an unknown donor, through Nationalmusei Vänner.

Page 51
Impression, Sunrise, Claude Monet, 1872, oil on canvas, 48 × 63 cm (18⅞ × 24⅞ in), Musée Marmottan Monet, Paris, France. Bridgeman Images.

Pages 52–3
The Pool at the Jas de Bouffan, c.1876, oil on canvas, 49 × 55 cm (19¼ × 21⅔ in), State Hermitage Museum, St Petersburg, Russia. Bridgeman Images.

Page 54
Portrait of Victor Choquet (Head of a Man), 1876–7, 46 × 36 cm

(18⅛ × 14⅛ in), Private Collection. Bridgeman Images.

Page 55
The Apotheosis of Delacroix, 1890–4, oil on canvas, 27 × 35 cm (10⅔ × 13¾ in), Musée d'Orsay, Paris, France. Fine Art Images/Heritage Images/Getty Images.

Page 56
The Bathers at Rest, 1876–7, oil on canvas, 82 × 101.3 cm (32¼ × 39⅞ in), The Barnes Foundation, Philadelphia, USA.

Page 57
Dish of Apples, c.1876–7, oil on canvas, 46 × 55.2 cm (18⅛ × 21¾ in), The Metropolitan Museum of Art, New York, USA. The Walter H. and Leonore Annenberg Collection. Gift of Walter H. and Leonore Annenberg, 1997, bequest of Walter H. Annenberg, 2002.

Page 58
The Riaux Valley near l'Estaque, c.1883, oil on canvas, 65 × 81.3 cm (25½ × 32 in), National Gallery of Art, Washington DC, USA. Collection of Mr and Mrs Paul Mellon.

Page 59
Portrait of the Artist's Son, c.1885, pencil on paper, 49 × 31 cm (19¼ × 12¼ in), Private Collection. Photo © Christie's Images/Bridgeman Images.

Portrait of the Artist's Son, 1881–2, oil on canvas, 38 × 38 cm (15 × 15 in), Musée de l'Orangerie, Paris, France. Bridgeman Images.

Page 60
Madame Cézanne in a Red Armchair, c.1877, oil on canvas, 72.4 × 55.9 cm (28½ × 22 in), Museum of Fine Arts, Boston, USA. Classicpaintings/Alamy Stock Photo.

Page 61
Madame Cézanne in the Conservatory, 1891, oil on canvas, 92.1 × 73 cm (36¼ × 28¾ in), Metropolitan Museum of Art, New York, USA. Bequest of Stephen C. Clark, 1960.

INDEX